IMAGES
of America

ANDERSON
ISLAND

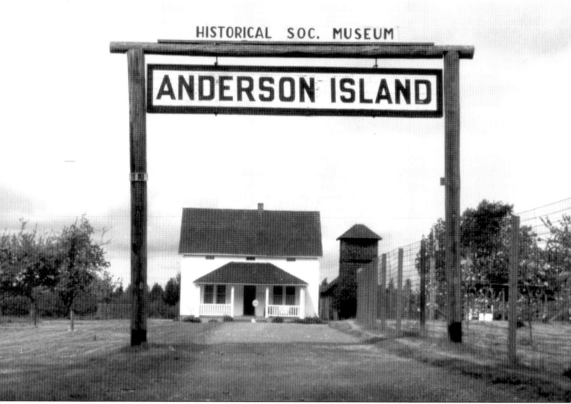

The Anderson Island Historical Society has preserved the 1912 Johnson farmhouse and surrounding farm, which today serves as an island historical landmark and museum. In 1975, Alma Ruth Laing donated the six-acre farm to the historical society. John and Karen Parks generously deeded an additional 20-acre parcel in 1991. The original Anderson Island ferry dock greeting sign, erected by the Anderson Island Community Club in 1926, now greets visitors at the farm entrance. (Courtesy AIHS.)

ON THE COVER: The Anderson Island schoolchildren pose for this 1904 class picnic photograph. Pictured here, from left to right, the children are (first row) Alice Johnson, Edna Ostling, Christine Anderson, Rupert Burg, Lelan Burg, John Youk, Otto Johnson, Ruth Johnson, and Ruby Burg; (second row) John Johnson, Dina Johnson, Oscar Johnson, Paul Camus, Albert Johnson, Mandus Engvall, Ben Johnson, Earl Youk, Grace Christensen, Elmer Burg, Bessie Johnson, unidentified, unidentified, Iva Burg, and Mary C. Cox (teacher). (Courtesy AIHS.)

IMAGES
of America

ANDERSON ISLAND

Elizabeth Galentine and the
Anderson Island Historical Society

ARCADIA
PUBLISHING

Published by Arcadia Publishing
Charleston SC, Chicago IL, Portsmouth NH, San Francisco CA

Printed in the United States of America

Library of Congress Catalog Card Number: 2006926073

For all general information contact Arcadia Publishing at:
Telephone 843-853-2070
Fax 843-853-0044
E-mail sales@arcadiapublishing.com
For customer service and orders:
Toll-Free 1-888-313-2665

Visit us on the Internet at www.arcadiapublishing.com

This book is dedicated to Alma Ruth Laing, who in 1975 so generously donated the six-acre Johnson Farm to the Anderson Island Historical Society for preservation of the 1896 Johnson farm and 1912 farmhouse.

CONTENTS

Acknowledgments

The idea for this pictorial history was sparked while accompanying Bmae Anderson to the November 2005 Tacoma Heritage League meeting. With her encouragement and the endorsement and support of the Anderson Island Historical Society, this book has become a reality. The majority of photographs were gleaned from the Anderson Island Historical Society archives. Special thanks go to the descendants of many early Anderson Island families and other longtime island residents who graciously opened their albums and shared their photographs.

With more than 500 photographs gathered, image selection for this book—restricted to 200—became a challenge. As I shared the work in progress with islanders, they began telling the stories behind unidentified and undated photographs. Ultimately, the photograph selection process took on a life of its own as so many pieces of island history were highlighted.

One night, Ralph Philbrook (a Carlson family friend) and I spent hours going through the Carlson photographs and memorabilia wondering why there were so many Cammons, only later to learn Emma Carlson's maiden name was Cammon. Cindy Haugen dropped off boxes of the Petterson, Johnson, Engvall, and Ehricke family albums, and Wes Ulsh, grandson of McNeil pioneer Charles Julin, brought McNeil Island back to life. Betsey Cammon and Burg family members contributed numerous photographs. Bob and Sarah Garmire, once residents of McNeil Island, verified several facts. Jeannie and Dene Ditmore and Toni Rex proofread the early drafts of each chapter, as did Vivian Gordon, who filled in many blanks for me.

Robin Paterson provided photographs and a historical perspective for the Mosquito Fleet chapter. Carolyn Marr and Ron Chaput of the Puget Sound Maritime Museum Historical Society, Joan Curtis of the Steilacoom Historical Museum Association, and Polly Medlock from the Tacoma Historical Society were extremely helpful. Bessie Cammon's *Island Memoir* and Hazel Heckman's *Island in the Sound* both served as references.

My editor, Julie Albright, provided support and advice while cracking her long whip. Also, a huge thank you goes to Jean Cammon Findlay and Lena Cammon, who spent days editing the final draft and verifying historical accuracy. Special thanks go to my friends and family for their patience and understanding, especially my husband, Dave.

INTRODUCTION

Anderson Island, located in Washington State's South Puget Sound, is a small island three miles wide and five miles long that boasts 14 miles of sandy beaches and high-bank waterfront. McNeil Island, home to McNeil Island Corrections Center, lies one-half mile to the north with historic Steilacoom, Washington, six miles to the east. Tiny Eagle Island, today a state marine park, sits in Balch Passage between McNeil and Anderson Islands. The Eagle Island lighthouse, long gone, once served as a beacon for steamships traversing the narrow passage.

Accessible only by ferry from Steilacoom or private watercraft, the island's remoteness has allowed Anderson Island to remain relatively isolated and unknown. Long considered a haven for retirees and a desirable summer vacation spot, the population as late as 1990 was only 548 permanent residents.

As a newcomer to this beautiful island, I became involved in community service projects that allowed me to befriend many longtime residents. These new friends introduced me to Anderson Island history through the stories they told about themselves and the people who had come before. A lifelong interest in history and a growing fascination with these stories led me to pursue this book about my new home.

As the island's history revealed itself, it became apparent that it is not the place, but the people who have made Anderson Island special. This book portrays only a small slice of that history. It was a privilege to be invited into the lives and histories of the early Anderson Island families through the photographs and stories of all those who so graciously shared them.

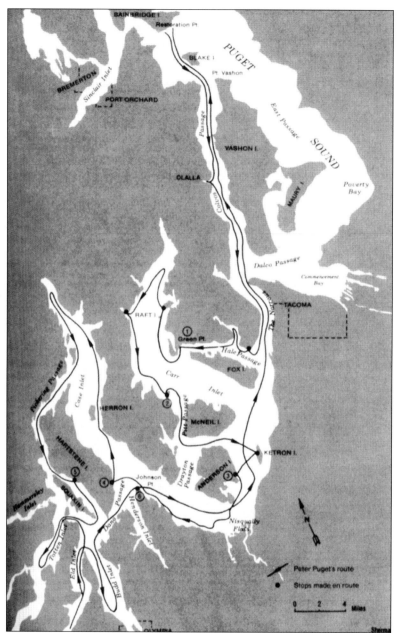

Capt. George Vancouver dispatched Lt. Peter Puget to conduct a detailed survey of the Southern Sound during the 1791–1794 British exploration of North America's Pacific Coast. On May 20, 1792, 16 men departed the main expedition ship, *Discovery*, in two small boats. The above map shows Lt. Peter Puget's route during his six-day surveying trip, with circled numbers marking where each night was spent. In Puget's account of day three, he wrote of taking shelter from a thunderstorm in a small cove (Oro Bay) on the east side of an island (Anderson Island). When they were forced to spend the night of May 22, 1792, three canoes carrying several Native Americans visited the camp in the evening. They offered gifts of wild raspberry shoots, arrow grass, and salmon. Puget eventually rose to the rank of rear admiral and died in 1822 in Bath, England. (Courtesy University of Washington Press.)

One

EARLY HISTORY

The Nisqually Indians called the island Klol-chks. They fished for salmon on the shores and harvested berries from the abundant plant growth. Lt. Charles Wilkes named it Anderson Island during his historic 1841 U.S. Exploring Expedition. In 1846, the British called it Fisgard Island, for their frigate. It was renamed Wallace Island in 1849 after Leander Wallace, who died in a Native American disturbance. The name Anderson Island was restored when the Washington Territory joined the Union in 1889 as the 42nd state.

The first recorded history of Anderson Island is Lt. Peter Puget's 1792 mapping trip through the South Sound. However, a more detailed glimpse of the island comes from the Luark diaries. In 1853, Michael Luark and his brother Patterson migrated to the Northwest. Each kept diaries, but Michael Luark describes an April 1854 woodcutting job on Wallace Island. His vivid account paints a picture of a heavy growth of timber with thick underbrush, briar, black huckleberries, and dogwoods. Venturing inward, Lurak discovered a body of water with a little stream, which expanded into another lake. These two fresh water lakes are known today as Lake Florence and Lake Josephine.

The U.S. Donation Land Claim Act of 1850 was enacted by Congress to promote homestead settlement in Pacific Northwest Oregon territory. Expiring in 1854, the land act offered free land to American citizens if they resided on and improved the land. Nathaniel Orr and Robert Thompson, both from Steilacoom, made claims on Oro Bay but never settled on the island and later sold their holdings.

The Christensen brothers, the first permanent island settlers, came from Denmark in the early 1870s and found their way to Anderson Island. John and Andrew Christensen established a logging operation on their property. Christian Christensen built a wharf and wood yard on Amsterdam Bay to service the steamships. When the young brothers sent for their sweethearts, the couples were married in 1872 in the Steilacoom Methodist Church, which today is marked by a monument.

By 1890, the population had risen to 22. These courageous and hardy Anderson Island pioneers paved the way for the expansive growth that was to occur in the early 1900s.

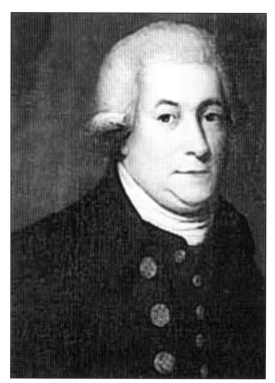

Capt. George Vancouver led the 1791–1794 exploration of North America's Pacific Coast aboard the HMS *Discovery* to survey the area, search for a northwest passage, and then circumnavigate the globe. Under his command was Lt. Peter Puget (1765–1822), who quickly established himself as skillful surveyor. For his accomplishments, Vancouver named Puget Sound for him and claimed the sound for Great Britain on June 4, 1792. (Courtesy NOAA.)

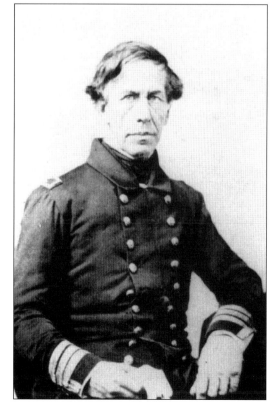

The purpose of the United States Exploring Expedition (1838–1842) was to provide accurate naval charts for the whaling industry and to establish an American presence in the region. Led by U.S. Navy Lt. Charles Wilkes, the expedition team was unsure of the welcome they would receive since the area was jointly occupied by Great Britain and the United States. Wilkes found the Hudson's Bay Company to be a good host and chief trader Alexander Caulfield Anderson especially cordial. (Courtesy NOAA.)

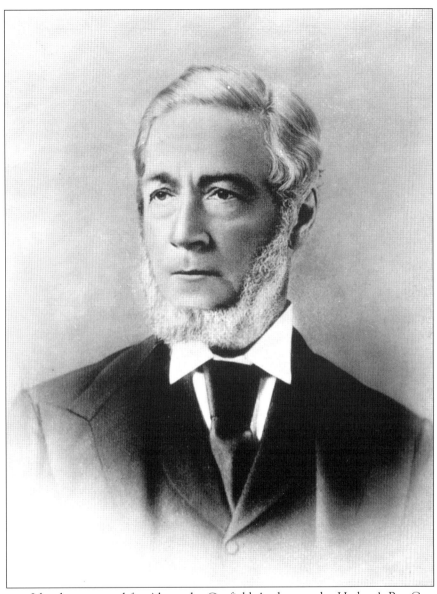

Anderson Island was named for Alexander Caufield Anderson, the Hudson's Bay Company's chief trader at Fort Nisqually during the years 1840 and 1841. For extending a warm welcome to the 1841 U.S. Exploring Expedition, Lt. Charles Wilkes named the island for him. Grandson of the famous Scottish botanist Dr. James Anderson, Alexander Caufield Anderson was born in Calcutta, India, in 1814 and educated in England. His father, Robert Anderson, a retired British Army officer, managed a successful indigo plantation in Bengal, but he returned to England in 1817 so his sons could receive a quality education. Anderson joined the Hudson's Bay Company in 1831, and he and his older brother came to Canada. He worked for the HBC in various forts and capacities from 1831 to 1858. Married in 1837 to Eliza Birnie, they had 13 children. Declining a promotion in 1854 that would have taken him to New Caledonia, he opted to retire at age 40 and stay in Cathlamet, Washington, so his children could attend school. In the 1860s, he became the Victoria, British Columbia, postmaster and held several other official positions before his 1884 death in Victoria. (Courtesy British Columbia Archives, Call No. A-01075.)

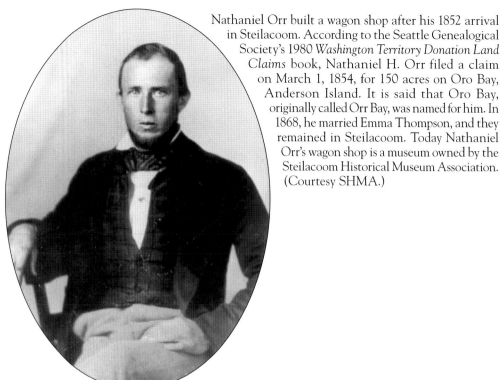

Nathaniel Orr built a wagon shop after his 1852 arrival in Steilacoom. According to the Seattle Genealogical Society's 1980 *Washington Territory Donation Land Claims* book, Nathaniel H. Orr filed a claim on March 1, 1854, for 150 acres on Oro Bay, Anderson Island. It is said that Oro Bay, originally called Orr Bay, was named for him. In 1868, he married Emma Thompson, and they remained in Steilacoom. Today Nathaniel Orr's wagon shop is a museum owned by the Steilacoom Historical Museum Association. (Courtesy SHMA.)

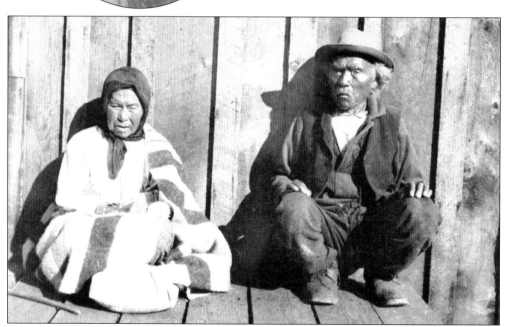

Known to islanders as Indian Mary and Indian Joe Lee, these two Nisqually Indians lived in Steilacoom. They fished on Anderson Island and frequently gave their catch to island residents. Erik and Else Anderson, after completing their Vega Bay home, gave their scow house, a large flat-bottomed boat with a small house built on top, to the Native Americans. The scow house was moored in Steilacoom. (Courtesy AIHS.)

The first permanent settlers on Anderson Island were the Christensen brothers—John, Christian, Hans, and Andrew. In the early 1870s, as seamen from Denmark, they made their way to America and eventually Anderson Island. Christian Christensen started a wood yard and built a dam to collect fresh water from springs at Amsterdam Bay to serve the steamships. The photograph at right shows two Christiansen brothers standing on a springboard several feet above the ground while working to fell a tree. (Courtesy Gene and Lyle Carlson.)

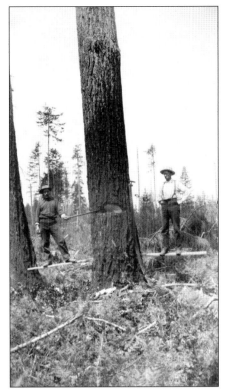

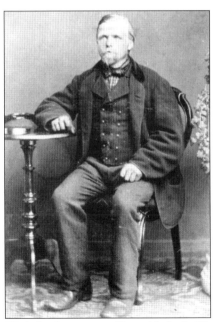

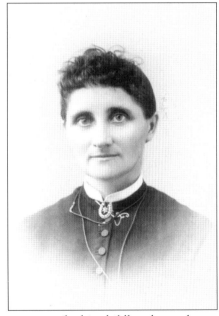

With his business well established, Christian Christensen sent for his childhood sweetheart, Helda Marie Cardell, and in February 1872, they were married. When Christensen died in 1887, he left his wife with six children and one on the way. Two years later, she married August Lindstrom, who also had a wood yard at Otso Point. Helda Christensen died in 1933. (Courtesy L. M. Cammon.)

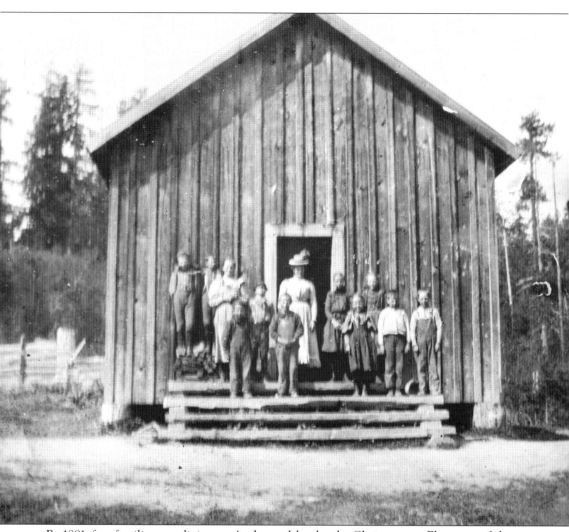

By 1881, four families were living on Anderson Island—the Christensens, Ekenstams, Johnsons, and Pettersons. With seven school age children and no schoolhouse, a schoolteacher was hired for the summer months and classes held in an abandoned house on Oro Bay. In August 1882, Pierce County School District No. 24 was established and a search began for a central location to build a schoolhouse. Peter Christensen donated 10 acres next to a small creek, and Nels Petterson was paid $60 to build the schoolhouse. Completed in 1883, this first building was constructed at the intersection of Ekenstam-Johnson and Sandberg Roads. In 1890, it was moved north near the present-day 1904 historic school building. Named by teacher Mary M. Eade, the school has been known since 1891 as Wide Awake Hollow School. (Courtesy AIHS.)

The Swedish translation for the name Ekenstam is oak branch. A big oak tree stands near the original location of the Ekenstam house at the south end of Ekenstam-Johnson Road. A grove of oak trees stands near the beach. The Ekenstam children, from left to right, are Albert, Edward, Louise, Elva, Amanda, and William. (Courtesy Dianne Avey.)

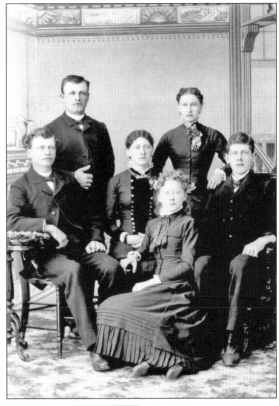

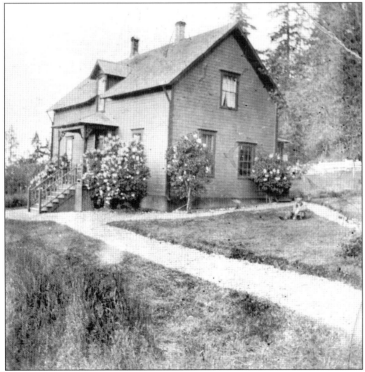

In 1877, John P. Ekenstam, a successful Swedish businessman, came to Anderson Island along with his wife, Ann, and their children. The Ekenstams built an elegant home of planed lumber, which was floated to the island from a mainland mill. Their home became the island's most elegant dwelling during that period. (Courtesy Dianne Avey.)

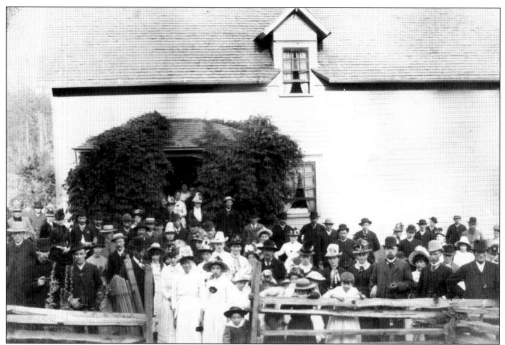

Many island gatherings were held at the expansive Ekenstam farm. Shortly after completing their house in 1877, many residents and visitors were invited to a gala event. Dressed in their finest clothing and hats, the guests pose for this photograph. Son William Ekenstam's hobby was photography, and many remaining island photographs can be attributed to his quality work. (Courtesy Dianne Avey.)

John Ekenstam purchased 212 acres on southern Anderson Island, probably from Robert Thompson of Steilacoom. The Ekenstam sons helped clear the land, and the family raised peas, wheat, and numerous fruit orchards. According to recordings of granddaughter Edna Ostling Myers, they purchased salmon for 5¢ apiece from the Native Americans. This photograph was taken on cold winter day in the late 1890s. (Courtesy Dianne Avey.)

Ornate tintype funeral remembrance cards, like the one at right, were common during the late 1890s. John P. Ekenstam died in 1896 at the age of 71. William and Edward Ekenstam, both bachelors, lived in the Ekenstam home until their mother's death in 1901. After the sale of the farm, they each purchased smaller places on Villa Beach Road. (Courtesy Cindy Haugen.)

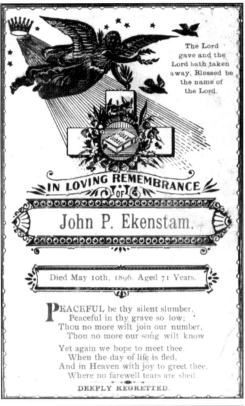

The Lord gave and the Lord hath taken away. Blessed be the name of the Lord.

IN LOVING REMEMBRANCE
OF

John P. Ekenstam.

Died May 10th, 1896. Aged 71 Years.

PEACEFUL be thy silent slumber,
Peaceful in thy grave so low;
Thou no more wilt join our number,
Thou no more our song wilt know

Yet again we hope to meet thee,
When the day of life is fled,
And in Heaven with joy to greet thee,
Where no farewell tears are shed.

DEEPLY REGRETTED.

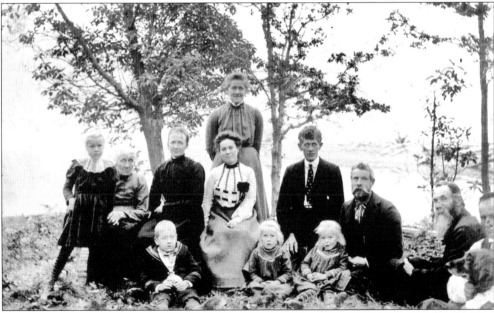

This photograph, taken shortly before Ann Ekenstam's death in 1901, shows a family gathering with her daughter Louise Ekenstam Ostling and her beautiful, blonde grandchildren, Edith, Evangeline, and Edna. May Dixon, who taught school on the island, is seated in the center in the white blouse. (Courtesy AIHS.)

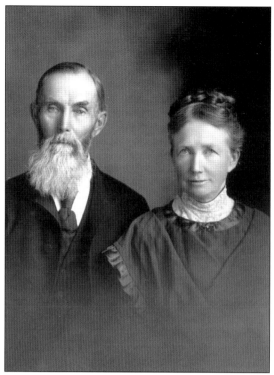

Bengt Johnson hailed from Vega, Sweden, and met Anna Nelson, also from Sweden, in Kansas. Married in 1879, they arrived on Anderson Island in 1881. They had five sons and two daughters. Emil Johnson died at one month and became the first burial on the island. Daughter Augusta married and moved to California. Daughter Bessie and her brothers Gunnard, John, Benjamin, and Otto, were lifelong island residents. (Courtesy AIHS.)

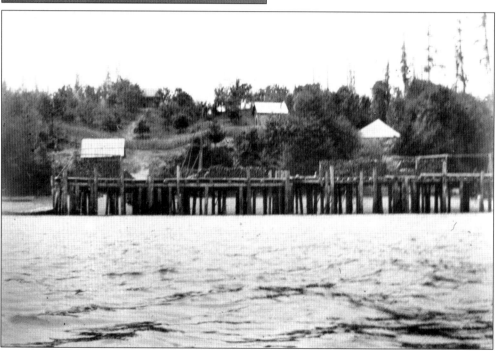

Recognizing the need for steamship cordwood, Johnson established a wood yard and built a dock to accommodate these ships. Johnson's Landing became a regular refueling stop. Growing up around the dock and steamships led all four Johnson boys to water-related careers, whether as captains or engineers. (Courtesy Betsey Cammon.)

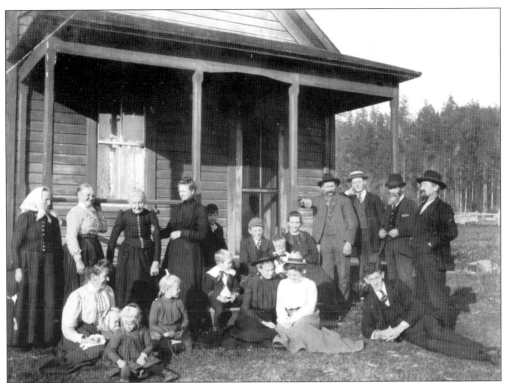

This photograph, taken at a Sunday dinner party in 1902, shows Anna Petterson standing to the far left in a scarf. Anna was originally from Sweden, and wearing a hat or head covering was customary for women in the Old Country. Purchasing 110 acres in East Oro Bay, Nels and Anna Petterson moved to Anderson Island in 1892. Nels Petterson died in 1919. (Courtesy AIHS.)

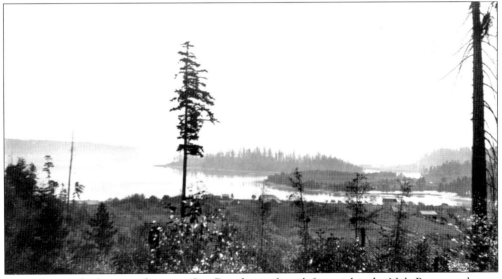

An early view looking south across Oro Bay shows, from left to right, the Nels Petterson home, Carl Petterson's farm, and the Ostling homestead. Mailman Point, the peninsula in the center, was the drop-off location for mail since steamships were unable to enter the shallow bay. (Courtesy Cindy Haugen.)

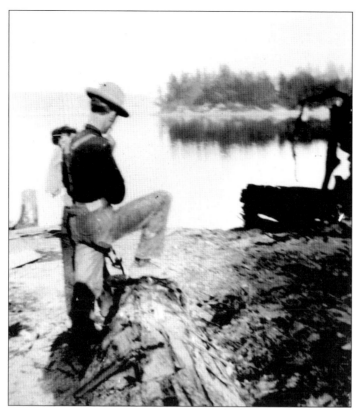

Arriving in 1888, Carl Gustaf and Josephine Malstrom Peterson brought six of their eight children with them from Sweden. After purchasing nine acres in the Villa Beach tract, Carl and his sons built a house and barn. In Sweden, it was customary for children to take their father's given name and add "son" to it, so the last name of the five sons became Carlson. Pictured at left, son Gus Carlson is working at Oro Bay where he built a dock and, in 1914, opened a general store. (Courtesy Gene and Lyle Carlson.)

Eleanor "Nora" Peterson frequently visited her cousin Lizzie Peterson Larson and her aunt and uncle Carl and Josephine Peterson, on Villa Beach. Residing with her parents in Tacoma, she is remembered for being a talented violinist who played at many island dance parties. In 1905, she and John Johnson, Bengt and Anna's son, were married. (Courtesy AIHS.)

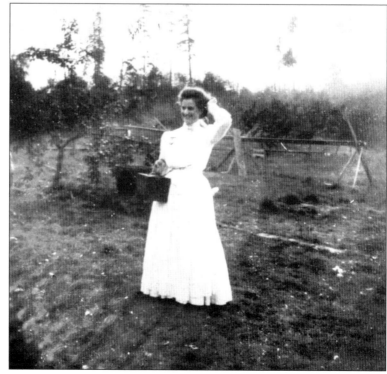

Purchasing 95 acres on the west side of Oro Bay, Jonas M. and Anne E. Johnson moved from Tacoma in 1907. This rare photograph of the interior of an Anderson Island home shows Anne on the left with other family members in the parlor. Their two sons, Sidor and Harry, were both gifted singers and entertained at many island parties. (Courtesy Cindy Haugen.)

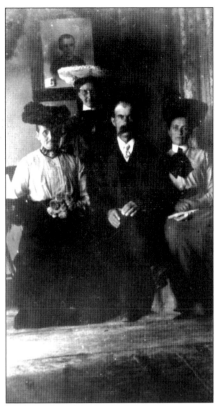

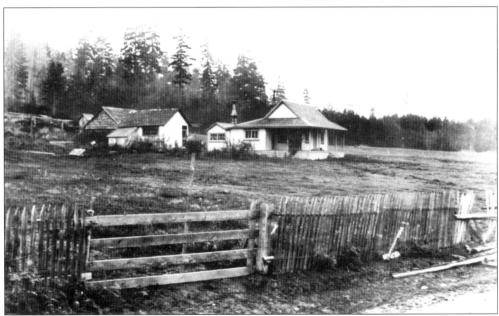

Sidor Johnson married Gerda Engvall, and they resided on their Oro Bay farm, pictured above, in the early 1920s. Daughter Sylvia Johnson married Bob Ehricke, and they made the island their permanent home. Son Lowell Johnson resided on the island most of his life and was an active community volunteer. (Courtesy Cindy Haugen.)

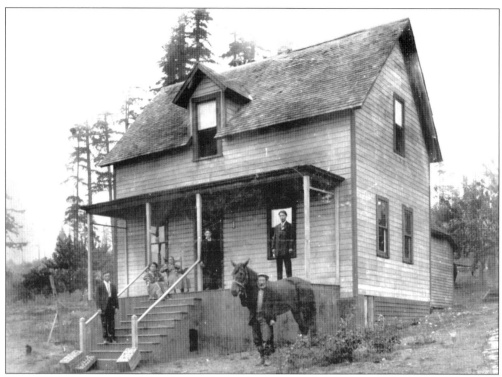

This 1908 photograph of the Camus home, built around the 1880s on Amsterdam Bay, is inscribed on the back as follows: "In Memory of Paul Camus. Born March 24, 1892, Anderson Island, Washington. Died August 27, 1982, Tacoma, Washington. Services September 1, 1982—1:00 p.m., Anderson Island Community Church. Officiated by Rev. Mark Benz. Interment Anderson Island Cemetery." (Courtesy Jon Clark and Victoria Mabus.)

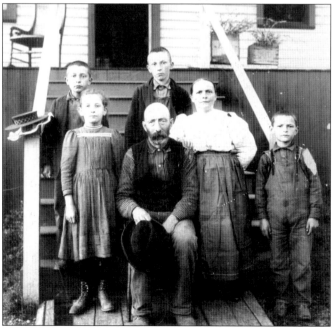

Arriving in 1890, the Camus family lived on Amsterdam Bay for many years. This 1915 family photograph shows Lena, Morris, Pauline, and Morris Jr. in the front row. In the second row are brothers Paul and Henry. Lena Camus married Dan Christensen in 1910. Paul Camus later inherited the home and lived there until he died. (Courtesy AIHS.)

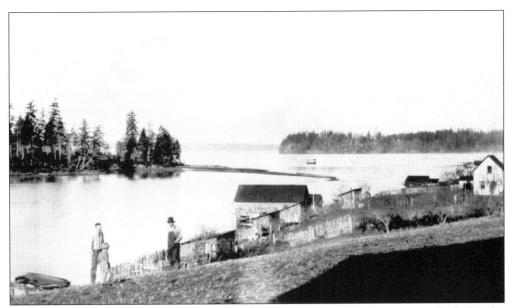

Amsterdam Bay, located on the west side of Anderson Island, has a spit that protects the little inlet from the sound. The southern and western exposure made it an ideal location for growing crops. Produce grown here was placed on skiffs and rowed out to passing steamships. This photograph, taken in the late 1920s on the Camus property, shows young Norm Camus with his two uncles, Al Ravnum and Paul Camus. (Courtesy Dianne Avey.)

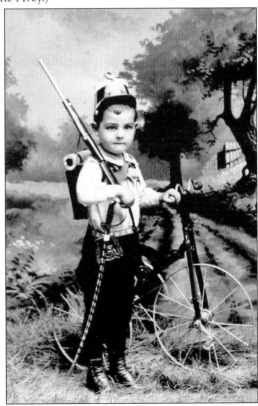

Young Frank Hodges, posing in a military uniform, attended school on the island from 1890 to 1893. His stepfather, Charles Alward, and his mother, Florence Hodges Alward, owned property north and east surrounding Lake Florence, including part of the lake. Lake Florence was named for Frank's mother. (Courtesy AIHS.)

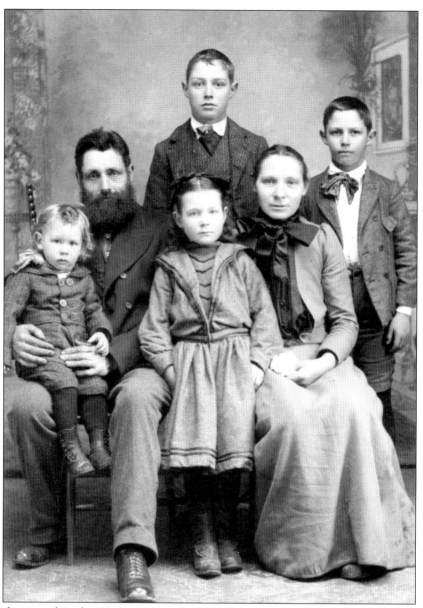

Erik Anderson and Andrew Soren Marinus "A. S. M." Anderson, friends in Denmark, reconnected in Tacoma when the whaling ship Erik Anderson was aboard docked in Commencement Bay. ASM Anderson said Anderson Island resembled their home, the Isle of Mors. Seeking waterfront property and a good fishing location, Erik Anderson purchased 10 acres in 1888 at Vega Bay from his friend. Those 10 acres were part of the original Ekenstam holdings. Sending for his sweetheart, Else Marie, they married and settled in Tacoma. Their first son, Neils, was born in 1890. Arriving on the island by scowboat in 1894, Erik and Else Marie Anderson had three more children—Andrew, Christine, and Alfred, who died at the age of three. Actively involved in the community, their motto was "if one takes from a community, one must give back." That motto is certainly true of the Anderson family, who spelled their name with an "o" as instructed by a Swedish schoolteacher who informed them that was the American spelling for Andersen. (Courtesy Randy and Bmae Anderson.)

Already an Anderson Island property owner, Peter Dahlgreen convinced August Burg also to purchase land. In October 1897, Burg brought his wife, Alphy Johnson Burg, and their four children, Iva Grace, Elmer, Lelan, and Rupert, to their Villa Beach property to live in a one-room temporary house. They had three more children, Ruby, Chester, and Mabelle. August Burg worked in Alaska for a season and then on several steamships. Pictured at right are August Burg and his grandson Jerry Burg. (Courtesy Jerry and Gail Burg.)

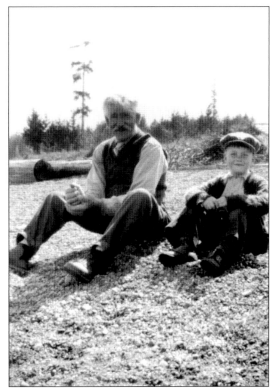

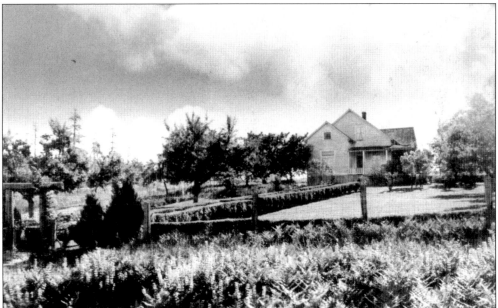

In 1898, August and Alphy Burg completed this home on Villa Beach. The two trees they planted at the end of the walkway still stand today. Son Rupert and his family occupied the home for many years, but tragedy struck in 1984 when the house caught fire and Rupert Burg died. Today this is the site of Burg's Landing, a lovely bed and breakfast run by Rupert's son and daughter-in-law, Ken and Annie Burg. (Courtesy Jerry and Gail Burg.)

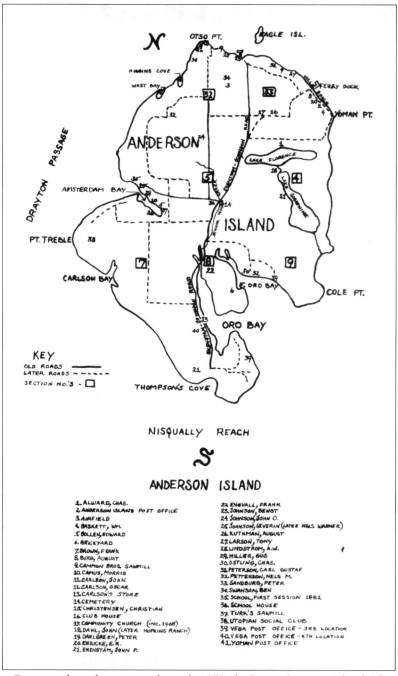

ANDERSON ISLAND

1. ALWARD, CHAS.
2. ANDERSON ISLAND POST OFFICE
3. AIRFIELD
4. BASKETT, WM.
5. BOLLEN, EDWARD
6. BRICKYARD
7. BROWN, FRANK
8. BURG, AUGUST
9. CAMMON BROS. SAWMILL
10. CAMUS, MORRIS
11. CARLSON, JOHN
12. CARLSON, OSCAR
13. CARLSON'S STORE
14. CEMETERY
15. CHRISTENSEN, CHRISTIAN
16. CLUB HOUSE
17. COMMUNITY CHURCH (INC. 1908)
18. DAHL, JOHN (LATER HOPKINS RANCH)
19. DAHLGREEN, PETER
20. ENRICKE, E.R.
21. EKENSTÁM, JOHN P.
22. ENGVALL, FRANK
23. JOHNSON, BENGT
24. JOHNSON, JOHN O.
25. JOHNSON, SEVERIN (LATER NELS WARNER)
26. KUTHMAN, AUGUST
27. LARSON, TONY
28. LINDSTROM, A.W.
29. MILLER, GUS
30. OSTLING, CHAS.
31. PETERSON, CARL GUSTAF
32. PETTERSON, NELS M.
33. SANDBURG, PETER
34. SWANSON, BEN
35. SCHOOL, FIRST SESSION 1882
36. SCHOOL HOUSE
37. TURK'S SAWMILL
38. UTOPIAN SOCIAL CLUB
39. VEGA POST OFFICE - 3RD LOCATION
40. VEGA POST OFFICE - 4TH LOCATION
41. YOMAN POST OFFICE

Jane Smart Cammon drew this map in the early 1970s for Bessie Cammon's book *Island Memoir*. Talented and artistic, Jane Cammon taught school on Anderson Island for a couple years during the early 1950s and developed many innovative projects for children. She married Russell Cammon, Bessie and Oscar Cammon's son. The Anderson Island Park and Recreation District dedicated the Cammon Field and Trail to Russ and Jane Cammon. The park, which comprises 40 acres, is the site of the Anderson Island Elementary School, the Russ Cammon Ball Field, and the Jane Cammon Walking Trail. (Courtesy Betsey Cammon.)

Two

SETTLEMENT

The early 20th century brought growth and prosperity to Anderson Island. Logging operations were in full swing, the brickyard hired many young men, the steamships made regular cordwood refueling stops at Johnson's Landing, and farms flourished. Children of the pioneers married, built homes, and started families. New settlers arrived and began developing the interior island land.

Pioneers first settled along the shorelines to the north and the south, and clusters of homes formed two tiny communities on the island. The northern and southern settlements became known by their post office names, Yoman and Vega. With only narrow trails for roads, islanders were forced to travel by boat to reach each other. Trails from homes on the east and west intersected the main north-south trail from Johnson's Landing to the Ekenstam farm. The first main road on the island, Ekenstam-Johnson Road, accommodated a wagon and enabled farmers to bring goods and produce to the steamers departing from Johnson's Landing. Connecting roads remained little more than trails for many years to come.

As the land was cleared to fuel steamships with cordwood, new Scandinavian settlers converted the pastures to farmland and raised produce to sell to the growing mainland communities. Among these new settlers were John Oscar and Alma Marie Johnson, who purchased land from Bengt Johnson (no relation). Developing a large farm, in operation until 1975, the Johnson Farm today has been preserved thanks to the donation from Alma Ruth Laing, the last surviving relative.

As the steamship era ended and small farms across the nation declined, the island population experienced a downward trend. Many children reached maturity and left the island for better opportunities. The population peaked in 1920 at 141 residents. The downward trend left the island with a 106 residents in 1950 and only seven school-aged children.

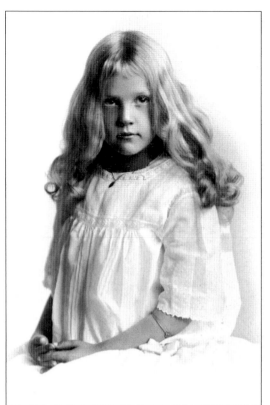

Anna Bertha Cammon, Bessie and Oscar's first child, is five years old in this photograph. A beautiful young girl with long blonde hair, Anna died in 1921 at age 14 of tuberculosis. The upstairs bedroom of the Johnson Farmhouse Museum contains her dollhouse, which is displayed with other children's toys and memorabilia from that period. (Courtesy AIHS.)

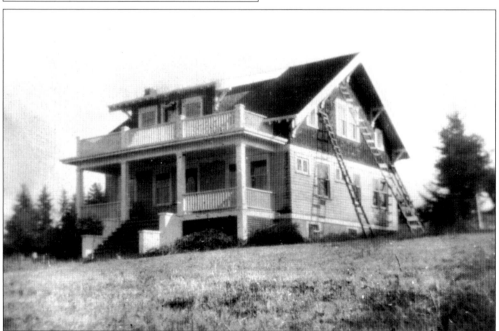

Oscar and Bessie Cammon built this house in 1916 on the north end of Anderson Island near Johnson's Landing. Bessie lived in the house for more than 60 years. Today her son Bob Cammon resides there. (Courtesy AIHS.)

Betsey "Bessie" Elizabeth Johnson Cammon authored the book *Island Memoir*, a classic local history for islanders. Born on Anderson Island on October 5, 1886, her baptism certificate reads "born on Wallace Island, Washington Territory"—Anderson Island was once known under this name. Attending normal school in Tacoma, she obtained her teaching certification in 1905 and accepted her first teaching position in Cowlitz County. She returned to Anderson Island and taught 33 students in grades one through eight. In 1955–1956, she was instrumental in organizing the *Island Gazette*, a youth fellowship-run newspaper published weekly in the summer and monthly during the winter. The back page contained an island history written by Bessie, and those articles were the basis for her later book. This photograph was taken shortly after her July 25, 1906, marriage to Oscar Cammon. They lived in Still Harbor on McNeil Island until 1916 when they returned to Anderson Island. (Courtesy AIHS.)

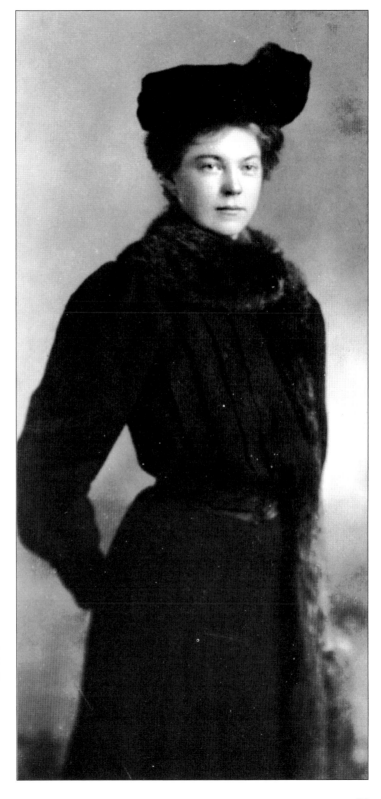

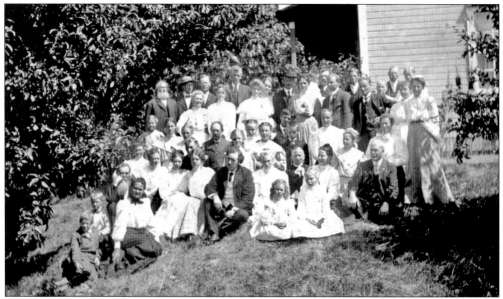

Many early island families are represented in this July 25, 1906, photograph taken at Oscar and Bessie Johnson Cammon's marriage, the first island wedding. The groom's father, Hans Kammen (the original spelling), is pictured to the far left in the fourth row. An early McNeil Island pioneer, this is the only known photograph of him and his wife, Inger Marie Kammen, who is in the second row to the far right kneeling, next to Oscar Cammon's stepdaughter Lizzie Michaelsen, standing. (Courtesy Betsey Cammon.)

A thorn between two roses seems to apply in this photograph of Ben Johnson, youngest son of Bengt and Anna Johnson. Ben chose a career in engineering and sailed on many vessels. In 1940, he married Mary E. Cox, who taught at Wide Awake Hollow School during the years 1934–1936 and 1944–1947. (Courtesy AIHS.)

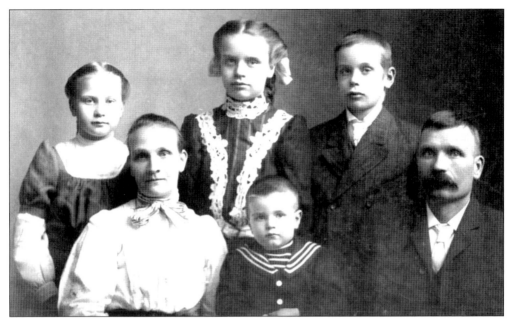

John Oscar and Alma Marie Johnson, both from Finland, met at the Swedish Lutheran Church in Tacoma. Married in 1891, they purchased 40 acres from Bengt Johnson, and in 1896, built their first house, a two-room cabin. Pictured here, from left to right, are (first row) Alma, Rudolph, and John; (second row) Ruth, Alida, and Oscar. Taking over the farm after their parents died, Rudy and Oscar ran a successful chicken and dairy enterprise. (Courtesy AIHS.)

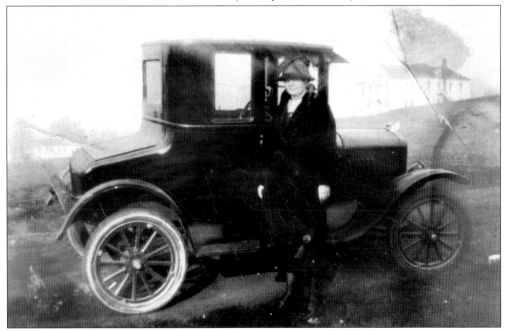

When Alma Johnson died in 1907, her oldest daughter Alida dropped out of school to help raise the family. Continuing her education afterwards, she was a 1922 Tacoma General Hospital nursing graduate and worked as a registered nurse. This 1919 photograph shows Alida with her new Model T. (Courtesy AIHS.)

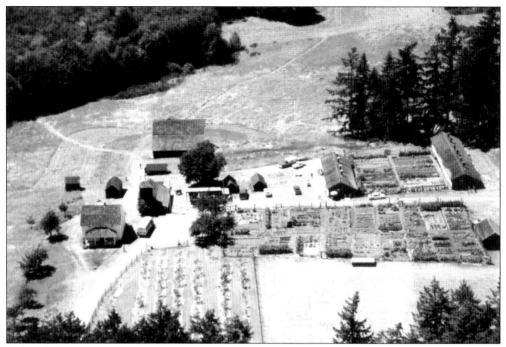

Today the Anderson Island Historical Society owns the Johnson Farm, which includes the 1912 farmhouse, a pole barn, two chicken coops, and several other outbuildings. Both the farmhouse and the chicken coops have been restored to house educational exhibits, antiques, a collection of children's toys, a gift shop, and a meeting room. Managed and maintained by volunteers, the farm is financed with donations and small grants. The AIHS conducts weekly tours of the Johnson Farm. (Courtesy AIHS.)

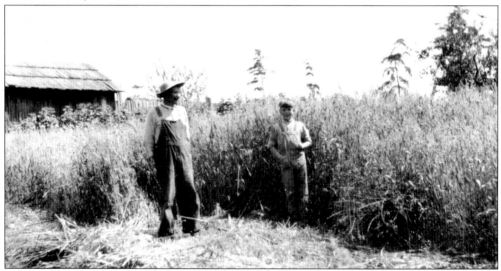

A hot, 1915 summer day of haying has John Johnson and his son Rudolph taking a break. Today the Johnson Farm is the center of activity during the summer and fall months. The annual salmon bake and apple squeeze draw hundreds to the island for these traditional events. Garden plots are rented to islanders, who in turn leave excess produce and flowers on a shelf, asking only for a donation. (Courtesy AIHS.)

While working in Tacoma, the Johnsons' daughter Ruth Alice Johnson met Alexander Laing in Spanaway. At that time, Laing was stationed at Bremerton with the U.S. Navy. They married in 1926, and their only child, Alma Ruth Laing, was born in Bremerton. Transferred to the East Coast by the navy, the family lived in several New Jersey and Pennsylvania communities. Alma Ruth attended school in Philadelphia and Trenton, New Jersey. Summers were spent with her mother, Ruth Johnson Laing, on the Johnson Farm, where she grew to love the island. After the death of Ruth in 1962, Alexander Laing and his daughter returned to Tacoma. Father and daughter visited the island weekly to assist Oscar and Rudy Johnson with the chicken and dairy farm. When Rudy Johnson died in 1975, Alma Ruth Laing inherited the entire Johnson Farm. Desirous of preserving the historic farm and encouraged by her father, Alma Ruth deeded the six-acre Johnson Farm to the Anderson Island Historical Society in 1975 to be set aside as a museum. Alma Ruth, an AIHS honorary member, continues to support the historical society by donating her time and attending all events. She and her father are pictured above c. 1940. (Courtesy AIHS.)

While working at the Anderson Island brickyard, Charley Ostling, born in Boden, Sweden, in 1866, met Louise Ekenstam. Married in 1894, they had three beautiful, blonde daughters, Edna, Evangeline, and Edith, and one son, Allan. Purchasing land, they built the elegant Victorian home pictured above and developed a productive farm. The house stills stands today on East Oro Bay. (Courtesy Dianne Avey.)

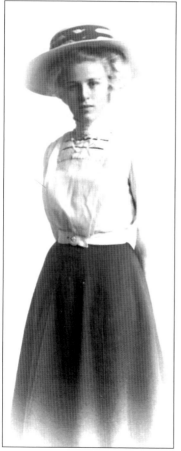

Edna Ostling, pictured here in 1914, attended college and taught school in Washington for many years. She and her sister Evangeline were talented singers. They formed a quartet with Sidor and Harry Johnson and entertained at many island community events. After marrying Perry Myers and moving to Longbranch, she continued to share her beautiful soprano voice in the choir and as a soloist. (Courtesy AIHS.)

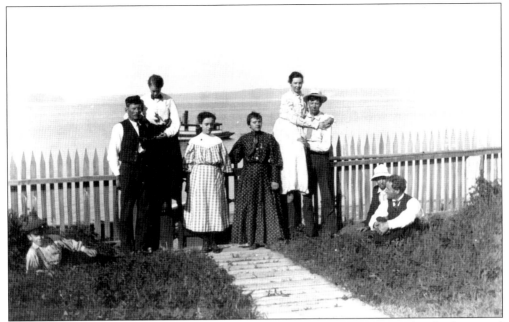

With the Cammon shrimp boat—the *Anna B*, anchored in the background—the Burgs and Johnsons enjoyed this 1906 day on Villa Beach. (Courtesy Dianne Avey.)

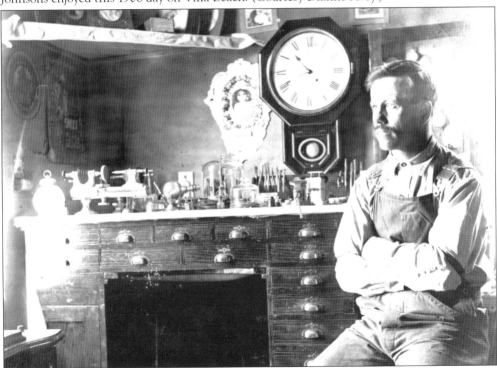

Bachelor Adolph Gertig moved to the island in the 1930s and lived on the south side of Amsterdam Bay. A retired locksmith and former operator of Lee's Repair Shop in Tacoma, he maintained clocks in his island home and donated a large wall clock to the community club, which still hangs on the wall. Gertig died in 1972 at the age of 81. (Courtesy AIHS.)

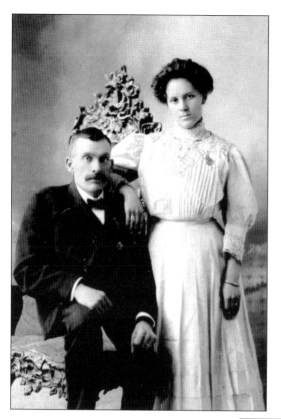

Moving from North Dakota, the Gulseths spent their first year in the area with his brother Peter Gulseth on McNeil Island. Son Clarence was born on McNeil. In 1911, Stephen, Esther, and Clarence moved to Anderson Island and purchased 60 acres, including waterfront, on Villa Beach, which is now Larson Road. (Courtesy AIHS.)

Clarence Gulseth, left, with his dog and a friend are standing in front of the large Gulseth home. It is said his father, Stephen Gulseth, planned to open the first hotel on the island. This plan did not come to fruition, and the home burned to the ground in 1978. It was clearly one of the largest homes on the island during those early years. (Courtesy AIHS.)

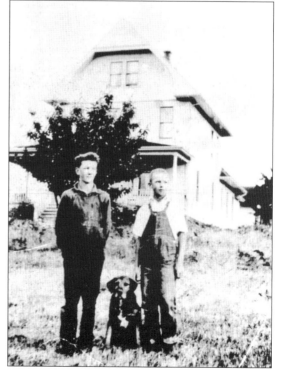

Carl Petterson, son of Nels and Anna Petterson, was a charter member of the McNeil Island Sunne Church and rowed his family to McNeil to attend Sunday services. Pictured with his family, he married John O. Johnson's sister, Hannah Johnson. Both were active in the community and remained on the Petterson farm on Oro Bay. (Courtesy Cindy Haugen.)

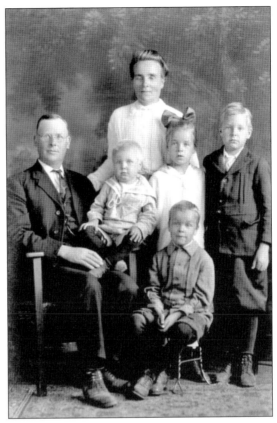

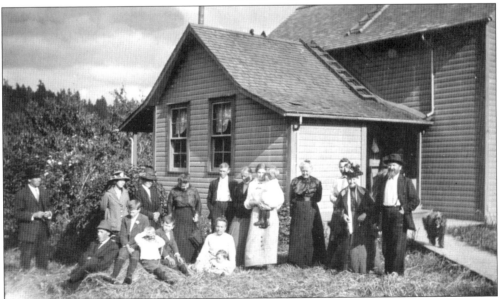

With no town center or community halls in the early 1900s, summer picnics and dinner parties were held at the homes of local residents. Visitors and relatives came from McNeil Island and as far away as Steilacoom and Longbranch. This c. 1914 gathering at the Ekenstam home shows Hannah Johnson Petterson (seated) holding her infant son Albert. (Courtesy AIHS.)

Andrew N. Christensen and Henrietta "Jetta" Marie Jensen married in 1872. Their first son, Hans Andersen Christensen, was the first male child born on the island. They eventually had seven more children. After an 1878 storm destroyed the logging operation owned by Andrew and his brother John, the family moved to Eatonville. Their second son Andrew Nelson Christensen and his family posed for this 1917 photograph. (Courtesy L. M. Cammon.)

Helda Christensen Lindstrom, second from left, poses with family and friends in front of her Amsterdam Bay home. Mary C. Cox, in front with the dog, was the schoolteacher in 1904 and boarded with families on the island. Since Helda Christensen was widowed, Mary could have been staying with her. (Courtesy L. M. Cammon.)

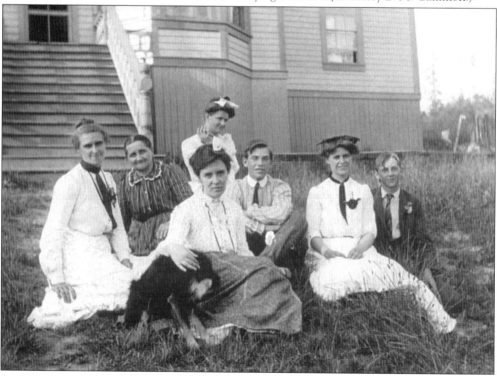

Christian and Helda Christensen's only son, Daniel, was eight years old when his father died. Daniel married Lena Camus Christensen on August 31, 1910, and they had one son, Ralph Daniel Christensen, born in 1919. Dan and Lena built a home at Otso Point on the island, and Lena was the Yoman postmistress for many years. Today their daughter-in-law Lorainne Christensen resides in the same home. (Courtesy Lorainne Christensen.)

Four generations of the Christensen family are pictured, from left to right, in this 1929 photograph: Helda Christensen Lindstrom, her grandson Fred Oros, daughter Cathrina "Kate" Sophia Christensen Oros, and her great-granddaughter June. Kate was 14 when her father, Christian Christensen, died. As the oldest child, she had been his helper and assisted in the wood yard business after his death. (Courtesy Lorainne Christensen.)

Gus Carlson and his sister Lizzie Peterson were lifelong residents of Anderson Island. Preferring her father's surname rather than the Swedish tradition of taking his given name, Lizzie remained a Peterson. She married Walter Larson of McNeil Island in 1915. Inheriting her parent's Villa Beach home, she lived there until 1936. In 1950, the house was struck by lightning and burned to the ground. Lizzie is remembered for having many friends and holding dances in the Peterson barn. (Courtesy Gene and Lyle Carlson.)

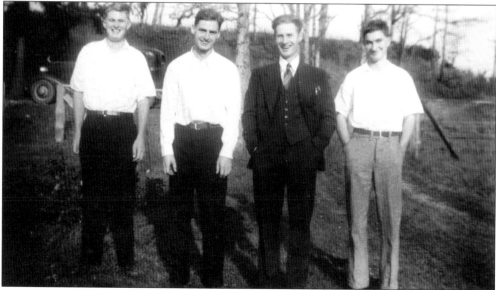

In this 1953 photograph, the smiling Carlson brothers, from left to right, are Gene, Donald, Lawrence, and Lyle. Gus and Emma Cammon Carlson married in 1909, had five sons, one who died at birth, and a daughter Helen. Gus Carlson died in 1937, but with the help of the boys, Emma was able to continue running the family grocery business. Today the store has closed, but the building remains, and both Gene and Lyle still reside on the island on the original homestead. (Courtesy Gene and Lyle Carlson.)

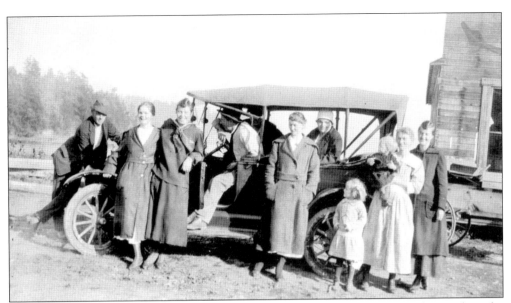

This 1914 photograph was taken at the opening of Carlson's Store, in the background on the right, at Oro Bay. Third from the left is Christine Anderson, who later inherited the Anderson family farm. It is said she purchased 100-pound bags of feed from the Carlsons and carried one on each shoulder. Emma Carlson is second from the right, holding baby Lyle. (Courtesy Gene and Lyle Carlson.)

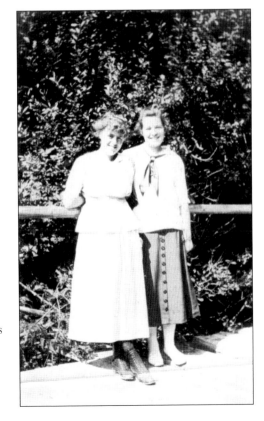

Edna Ostling (left) and Christine Anderson were lifelong friends. After the death of her mother, Christine spent many days at the Ostling home under the careful watch of Edna's mother, Louise Ostling. These two arm-in-arm friends are leaning against the schoolhouse creek bridge, which led to the Wide Awake Hollow School, where they both attended school c. 1915. (Courtesy Dianne Avey.)

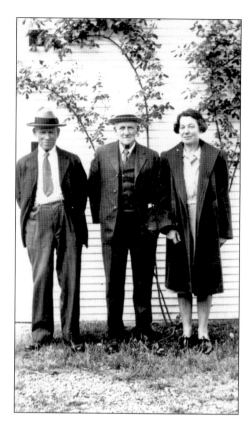

Bachelors Frank and Charley Johnson lived next door to the Anderson family at Vega Bay. The brothers, pictured with Christine Anderson, both worked at the brickyard until its closure. Afterward, they improved their land, raised chickens, and had a small dairy farm. Known as good community-minded islanders, they are interred in the island cemetery. (Courtesy Bmae and Randy Anderson.)

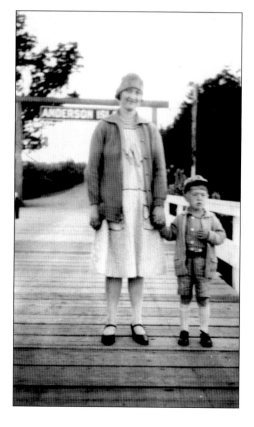

After returning from World War I France in 1919, Neils Anderson married Jennie Rand, and they settled in Tacoma. Son Norman lived with his Aunt Christine after she inherited the farm in 1932, and Norman's younger brother Randall lived there during the summers. Both boys helped with the farm work. A young Norman Anderson and his mother, Jennie, are standing on the ferry dock. (Courtesy Bmae and Randy Anderson.)

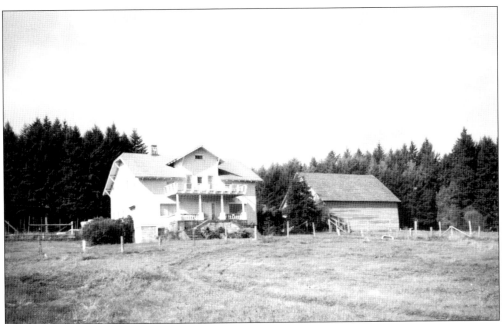

Known as Chicken Billy, William Anstet made his fortune selling chickens and eggs to Skagway, Alaska, gold miners and built this large home. Originally the ASM Anderson property, Randy and Bmae Anderson purchased the home in 1983. Bmae Anderson, a well-known artist and writer, completely renovated the home. Overlooking Vega Bay, today it is a luxurious bed and breakfast appropriately named the Anderson House. (Courtesy Earl and Jean Gordon.)

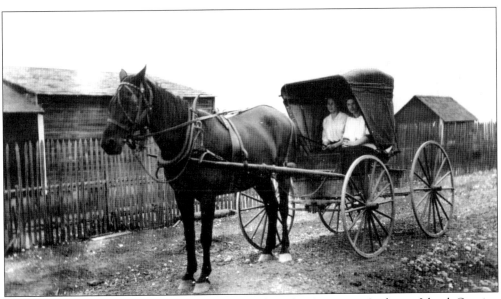

Before his financial problems, Peter Sandberg purchased 300 acres on Anderson Island. Owning a splendid home in Tacoma, Sandberg brought his wife and daughter Esther to the island for holidays and summers. Esther brought her horse and buggy to the island and navigated the few rugged island roads. Harry and Mary Thorberg purchased the property later, platted it, and sold lots. (Courtesy AIHS.)

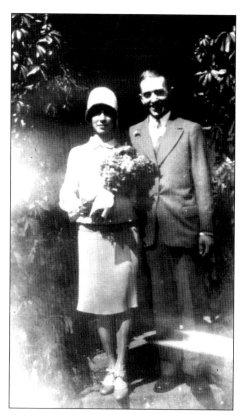

This 1929 photograph was taken the day Chester Burg and Edna Anderson married. They worked as caretakers on the Charles B. Hopkins Ranch for several years. Burg served on the island school board and was clerk of the board for five years. They later moved to Steilacoom. (Courtesy Jerry and Gail Burg.)

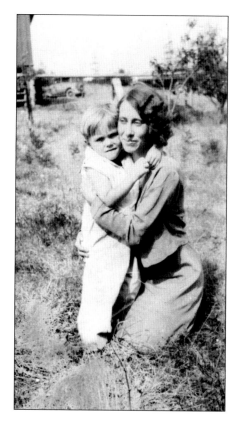

Edna Burg and her son Gerald, known as Jerry, share a hug at grandma Lina Anderson's house on Sandberg Road. Jerry grew up on the island, attending school at the Wide Awake Hollow School. He married his childhood playmate, Gail Snively, in 1979, and they reside on the original Burg property today. (Courtesy Jerry and Gail Burg.)

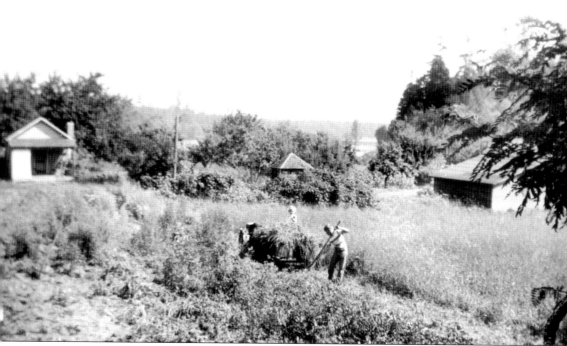

Born in 1855, Charles B. Hopkins, an enterprising young man, became the owner and publisher of the *Colfax Gazette* in Eastern Washington. Learning of the new "talking instruments," he purchased telephone wire at an auction for $30 and successfully installed the first long distance telephone service near Spokane. Marrying Josephine Davenport in 1880, he accepted the appointment of U. S. marshall for Washington State in the early 1900s. When the district was divided, Western Washington and the McNeil Island prison were under his jurisdiction and headquartered in Tacoma. In 1906, Hopkins purchased 400 acres on Anderson Island, which included parts of both island lakes. He brought his wife, Josephine, and two daughters to the island for the summers. Hopkins possibly provided support for the 1917 intra-island telephone service installation. With the assistance of August Burg, a road and cabin were built on the property. Lake Josephine, named for Josephine Hopkins, can be seen in the background as Jerry Burg and a friend work at the Hopkins Ranch in the 1940s. (Courtesy Jerry and Gail Burg.)

Born in 1863, Tony Larson worked at the Anderson Island brickyard and at the Johnson's wood yard after the brickyard closure. He lived in a cabin built specifically as sleeping quarters for the hired men. He left the island briefly but returned and built a home in the Villa Beach tract. (Courtesy AIHS.)

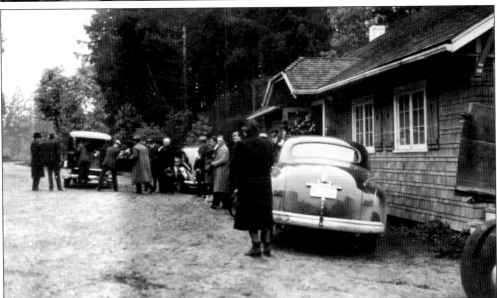

Well liked on the island and remembered for his love of horses, Tony Larson's funeral was held on a cold January day in 1942 at the community club clubhouse. Before the church was built, many funerals were held at the clubhouse, with gravesite services following at the island cemetery. (Courtesy AIHS.)

Three

THE MOSQUITO FLEET
AND BEYOND

When the Hudson's Bay Company ship, the *Beaver*, steamed through the Puget Sound in 1836, it marked the opening of a major water transportation corridor in the Northwest. Stretching from Olympia to Victoria, freight and passenger movement by steamship from the 1850s to the 1930s became a routine mode of travel and transport. With thousands of steamships plying the waters of Puget Sound, people said they resembled a swarm of mosquitoes, and they were dubbed the "Mosquito Fleet."

By 1859 when the side-wheeler *Eliza Anderson* established regular service between Olympia and Victoria, frequent cordwood refueling stops connected remote and otherwise inaccessible small communities to larger markets. Johnson's Landing, built by Bengt and Anna Johnson on the north end of Anderson Island, became a frequent refueling stop for many of these steamships. Islanders sold or exchanged produce and goods and traveled easily to other larger communities.

Floating grocery store vessels, such as the *Otter*, made weekly stops at both Anderson and McNeil Islands. Lumber from the island was shipped to locations as far south as San Francisco, and a regular mail service was established. Passengers traveled on the luxurious *Multnomah*, making trips to other Northwest locations as evidenced by early postcards sent to relatives. Many island families owned some type of watercraft, using it for either professional fishing or local transportation between the islands and the mainland.

Competition from rail transportation and major highway systems in the 1930s gradually put the Mosquito Fleet out of business. A fleet of diesel-electric automobile ferries came to Puget Sound after the completion of the Golden Gate Bridge in 1935 and replaced the old Mosquito Fleet vessels. In 1922, the *Elk* made the first auto ferry run from Steilacoom to Anderson Island, McNeil Island, and Longbranch. The heyday of the Mosquito Fleet had ended.

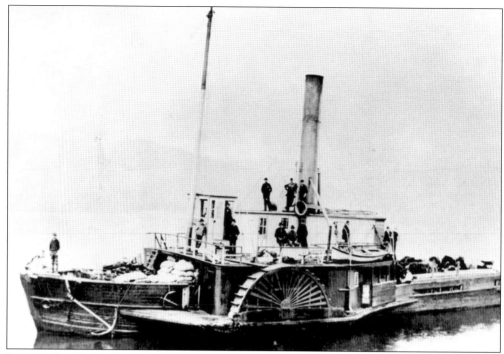

Launched in England on May 5, 1835, the HMS *Beaver* sailed across the Atlantic, around Cape Horn, and arrived at Fort Vancouver in late 1835. After paddle wheels were installed, the SS *Beaver* was assigned to the Fort Nisqually Hudson's Bay Company and served as a passenger and cargo vessel throughout Puget Sound. The SS *Beaver* was the first steamship in the north Pacific and operated until July 26, 1888. (Courtesy PSMHS.)

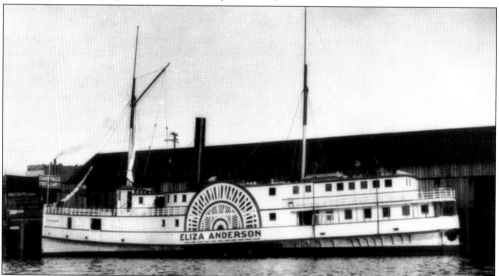

Despite her lack of speed, the *Eliza Anderson* became a gold mine for Capt. D. B. Finch. With the U.S. mail contract, no competition, and $20 passenger fares, Finch held a monopoly on the Olympia to Victoria route for 10 years. In 1866, Bing Crosby's grandfather, Nat Crosby, launched one of the strongest attempts to break the monopoly, but the *Eliza Anderson* continued running for another 20 years. (Courtesy PSMHS.)

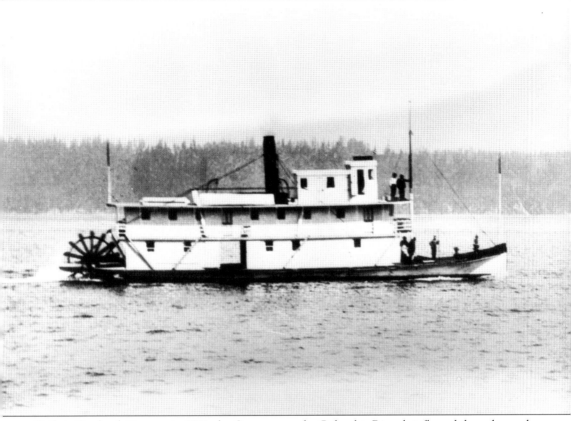

Built in Portland, Oregon, in 1872, the *Otter* ran on the Columbia River briefly and then changed hands several times. Capt. Roscoe G. Brown and his cousin C. A. Brown purchased the *Otter* and converted the wood-burning stern-wheeler to a floating grocery store. With their base of operation in Tacoma, the *Otter* made weekly trips to numerous communities south of the Narrows, including Anderson Island and McNeil Island. With no stores on the either island at that time, the weekly stops, bringing groceries and other merchandise, were a godsend. After tying up at Johnson's Landing, the crew became clerks, and island residents perused the store's merchandise, stored in boxed shelves to keep the contents from sliding during sailing. Many island farmers often exchanged their produce for merchandise. The *Otter* sank near Des Moines after colliding with the stern-wheeler *Hassalo*. (Courtesy PSMHS.)

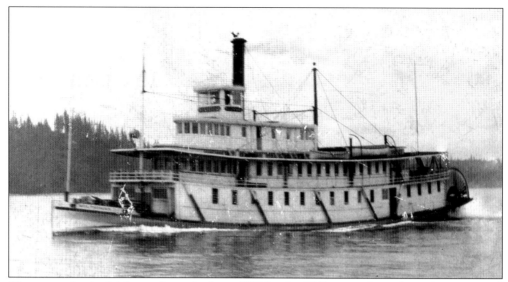

The stern-wheeler *Multnomah* was built in 1885 by the Willamette Steamboat Company and sold to the Olympia-Tacoma Navigation Company in 1889. The *Multnomah* made many stops at Johnson's Landing to refuel with water and cordwood and deliver and pickup freight and passengers on her Seattle–Tacoma–Olympia run. While entering Elliot Bay during a dense fog, the *Multnomah* was rammed and sank on October 28, 1911. (Courtesy AIHS.)

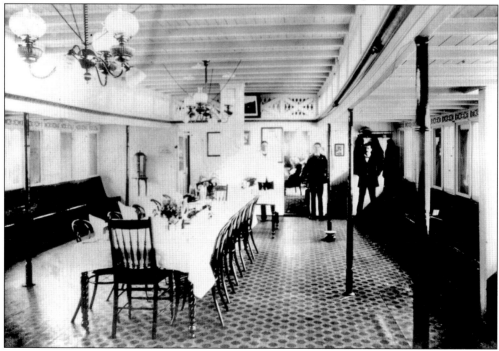

In addition to freight delivery, the *Multnomah* carried passengers who rode in one of the three main compartments. Between the men's cabin, which allowed smoking, and the ladies' cabin, with thick red carpet and cushioned seats, was an elegant dinning cabin. Anna Johnson often supplied flowers from her garden for the white linen-covered tables. In exchange for the flowers, the steward would leave a copy of the *Tacoma Ledger*. (Courtesy Tacoma Historical Society.)

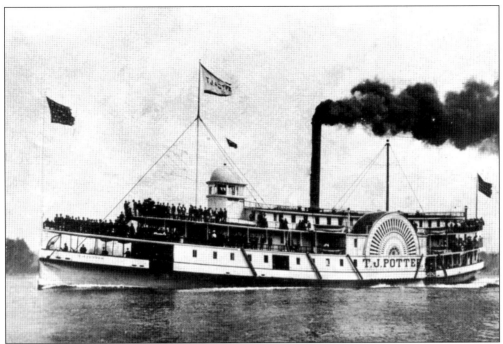

The elegant *T. J. Potter* was known as one of the Puget Sound speed queens. Built in 1888 in Portland, this side-wheeler once raced against the famous *Bailey Gatzert*, named for a Seattle mayor, and set a new speed record of 82 minutes from Tacoma to Seattle. (Courtesy PSMHS.)

The *Politofsky*, once a Russian Navy gunboat in Alaska, sailed the Puget Sound waters for a generation as a tug and passenger carrier. In 1897, the "Polly," as she was nicknamed, was converted to a barge, towed to Nome, Alaska, by the tug *Richard Holyoke*, and ended her long life there around 1905. (Courtesy PSMHS.)

Docked at Johnson's Landing c. 1900, the *Northern Light* was one of the early stern-wheelers that delivered cargo and refueled here. Built in Seattle in 1898, she ran in opposition to the *City of Shelton* on the Shelton–Olympia route for a short time. By 1902, the *Northern Light* was transporting hay and garden produce between Shelton and LaConner. (Courtesy AIHS.)

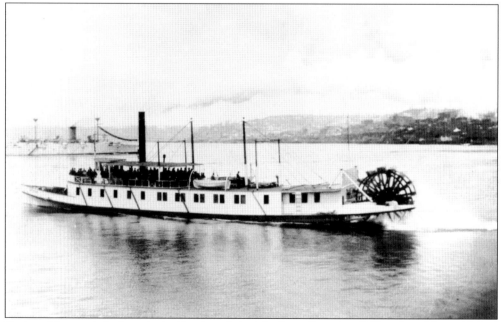

Designed for speed, the long, lanky *Greyhound* plied the Puget Sound in 1890 and quickly established herself as a dependable, fast stern-wheeler on the Olympia–Seattle run. Affectionately known as the "Pup," she left other steamers in her wake, but she met her match when she raced against the *Bailey Gatzert* and lost. Steamboat races were common during this time of competitive rivalry. Johnson's Landing was a regular stop until the "Pup" retired in 1911. (Courtesy PSMHS.)

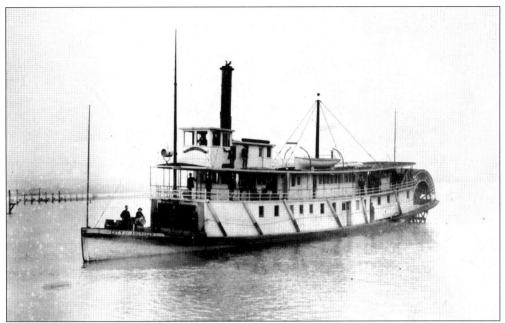

Built in 1891 in Grays Harbor, the *City of Aberdeen* entered the Puget Sound passenger trade. She spent most of her time quietly running between Seattle, Tacoma, and Olympia but occasionally caught racing fever. She once took on the famed stern-wheeler *Greyhound* and beat her—to the amazement of her crew. She met her end in 1908 on the Duwamish River near Seattle. (Courtesy Robin Paterson.)

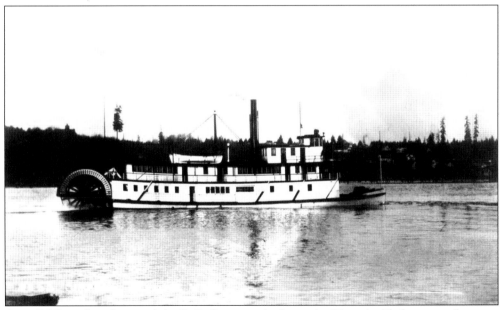

Capt. Ed Gustafson skippered the *S. G. Simpson*, which ran the Olympia–Shelton route for many years. Launched in 1907 from Tacoma's Crawford and Reid Yard, the *S. G. Simpson* was built for the Shelton Transportation Company. She was named for Solomon G. Simpson, founder and owner of the Simpson Logging Company. This photograph was taken around 1912 in Olympia, Washington. (Courtesy Robin Paterson.)

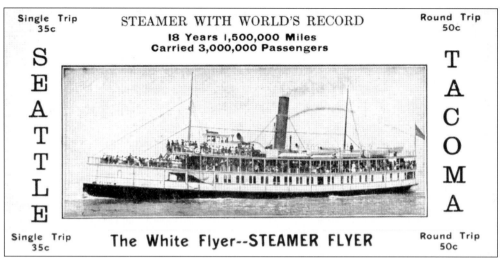

When Peter Dahlgreen of Oro Bay, Anderson Island, started his 1909 business casting propellers, his timing was impeccable. Steamers were just starting to change over to propellers, and the *Flyer* was one of the early boats he serviced. (Courtesy Robin Paterson.)

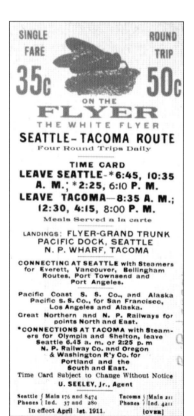

Using the new propellers instead of paddle wheels, "Fly on the Flyer" was a standard slogan for the steamer *Flyer*. She raced between Seattle and Tacoma, making four round-trips a day. By 1911, competition had now forced fares lower and made traveling to Seattle almost commonplace. (Courtesy Robin Paterson.)

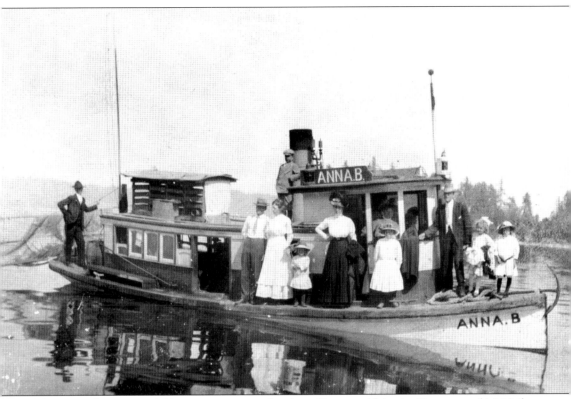

After several unsuccessful business ventures, brothers Oscar and Martin Cammon, of McNeil Island, established a shrimping company. When their first boat, the *Zillah*, proved to be too small, they worked odd jobs to earn enough to enlarge the boat. With their success firmly in place, they ordered a still larger boat, and in 1903, the *Anna B* was built at the Sipple Boat Yard in Longbranch. The Cammon brothers also maintained a boat shop in Still Harbor on McNeil Island. It is said that Martin Cammon named the *Anna B* for his first girlfriend, Anna Butsch of McNeil Island, but others insist it was for Oscar Cammon's daughter who, incidentally, was not born until 1907. In 1906, Oscar married Bessie Johnson Cammon, and in 1916, they moved to Anderson Island where Bessie had been raised. This photograph, with Oscar, Bessie, their daughter Anna, and friends, was taken in Still Harbor on McNeil Island. (Courtesy AIHS.)

The *Emrose*, owned by the Hunt brothers of Gig Harbor, serviced the Tacoma–Allyn route, making frequent stops on McNeil and Anderson Islands. As a propeller tugboat, she carried mainly freight, which was loaded through the wide entrance pictured above. The *Emrose* was built in 1911 and abandoned in 1930. (Courtesy Robin Paterson.)

Another Cammon boat, the *Trio*, cruised to Shelton on this October 1911 Sunday. Pleasure outings between the islands and the mainland gave island residents a chance to visit with friends and relatives. Many islanders used their boats for multiple purposes, such as fishing and passenger transport. (Courtesy Dianne Avey.)

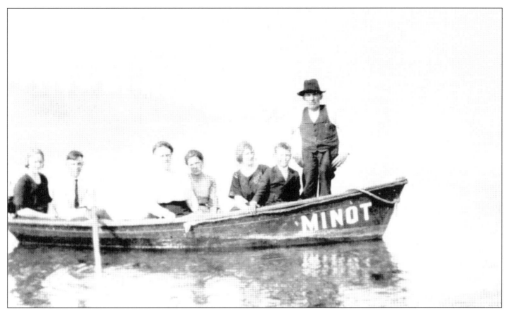

Named for his hometown of Minot, North Dakota, Stephen Gulseth is standing in his boat, the *Minot.* Peter and Margaret Gulseth, Stephen's brother and sister-in-law, lived on McNeil Island, and family visits between the islands were a frequent occurrence. (Courtesy AIHS.)

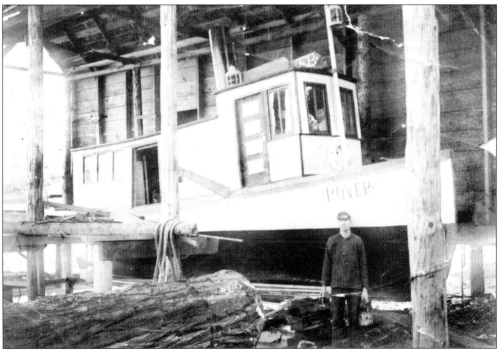

Gunnard Johnson, the oldest son of Bengt and Anna Johnson, pictured with his boat the *Rover* at the Cammon Shop in Still Harbor on McNeil Island, had a long water-related career. He and his wife, Hattie Johnson, lived in Seattle during his early years working on the upper Puget Sound. As part owner of the Anderson Tow Boat Company, they moved back to Anderson Island in 1934. (Courtesy AIHS.)

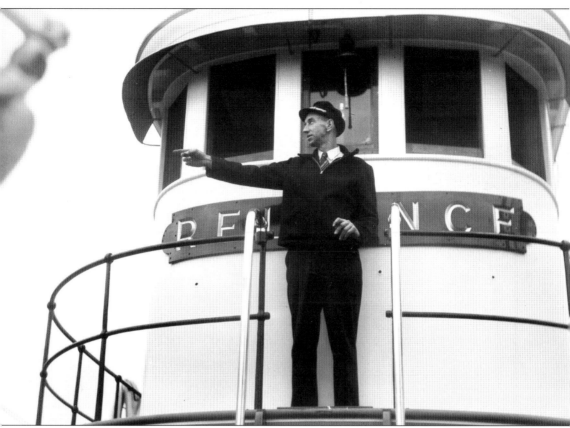

Capt. Otto Johnson, born and raised on Anderson Island, was a senior skipper with the Washington Tug and Barge Fleet. Johnson's Landing, owned by his parents, gave him an early exposure to life at sea. He, along with his older brothers, trained as deckhands and all four had some type of water-related career. Otto Johnson gradually worked his way to a licensed Puget Sound captain. As captain of the tug *Reliance* for many years, he traveled as far as Los Angeles in the 1930s. He later took over as captain of the larger tug *Tartar*. Married in 1967, Otto Johnson and Agnes Lindsay of Amsterdam Bay lived on the island for their remaining years. Otto Johnson died in 1976, and Agnes Lindsay Johnson died in 1978. They are both interred in the Anderson Island Cemetery. (Courtesy PSMHS.)

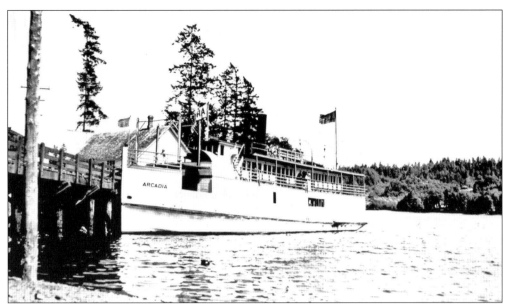

One of the last steamboats to operate on a regular route, the *Arcadia*, built in 1929 for the Lorenz, Berntson Company, ran between Tacoma and Lakebay. Skippered for 12 years by Capt. Bert Berntson, the *Arcadia* was purchased by the Federal Penitentiary on McNeil Island in 1942, renamed the *J. E. Overlade*, and ran for another 15 years. (Courtesy Cindy Haugen.)

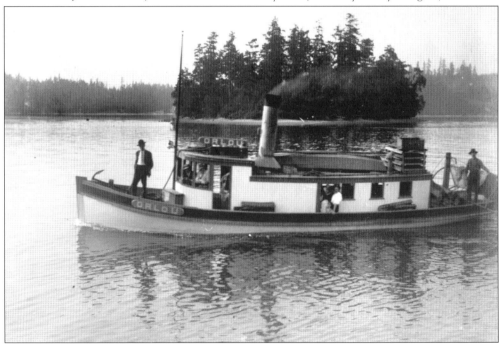

Another island grocery boat in the 1900s was the *Orlou*. She transported goods to the Carlson Store on the south end of the island and Johnson's Landing on the north end. Once the freight was received, Gus Carlson then delivered the goods to customers using a horse and wagon. With Eagle Island in the background, the *Orlou* appears to be headed for Johnson's Landing. (Courtesy Dianne Avey.)

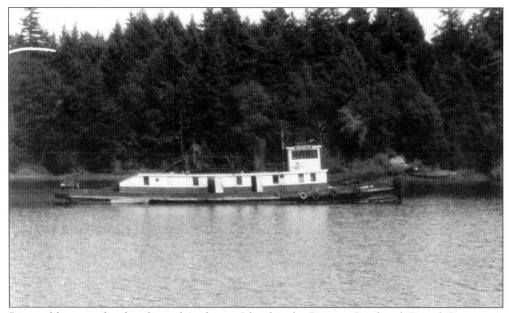

Pictured here on the shoreline of Anderson Island is the Pioneer Sand and Gravel Company's tugboat *Anne W*, skippered by Capt. Gunnard Johnson of Anderson Island in the 1930s. (Courtesy Earl and Jean Gordon.)

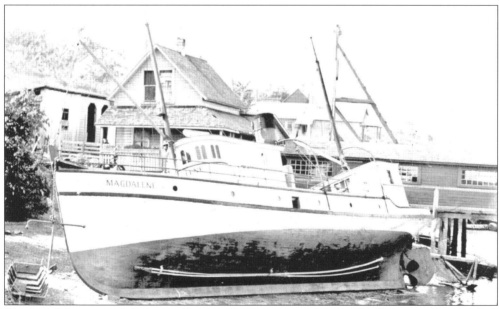

The *Magdalene*, one of the many Cammon boats, pictured here at the Cammon Shop in Still Harbor on McNeil Island, is careened for hull maintenance. Boats were brought out of the water at high tide and cleaned, as hull cleaning was required maintenance to ensure optimum boat speed. When the boat bottom is fouled, the vessel's speed is greatly reduced. (Courtesy AIHS.)

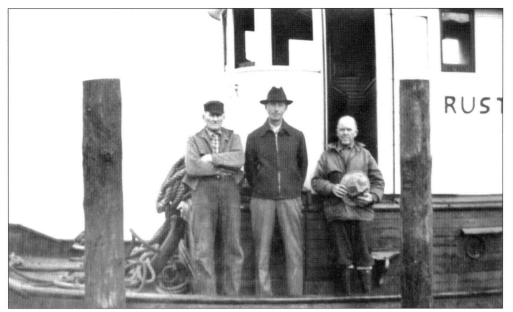

Oscar Cammon purchased the tugboat *Rustler* from the Pioneer Transport Company on February 3, 1933. Cammon, Melvin Evenson, and probably Aug Olson are pictured above. Aug Olson and his wife, Berte, the first woman ferryboat skipper on Puget Sound, owned the Deception Pass Ferry Company, which ran ferry service between Whidbey, Camano, and Fidalgo Islands. When the Deception Pass Bridge was completed in 1935, the company went out of business, and Aug Olson skippered ferries running to Anderson Island. (Courtesy AIHS.)

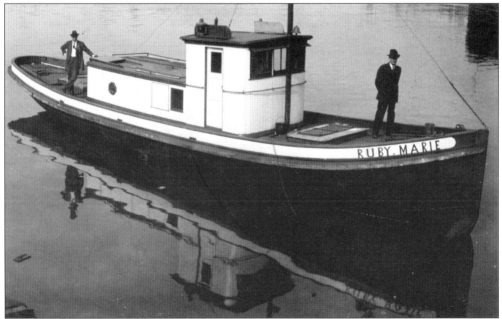

Gus and Emma Carlson moved from McNeil Island to Anderson Island in 1914 and opened a grocery store at Oro Bay on the southern end of the island. After struggling for several years to move inventory and supplies, Carlson purchased the *Ruby Marie* to service customers by making waterfront pickups and deliveries. (Courtesy Gene and Lyle Carlson.)

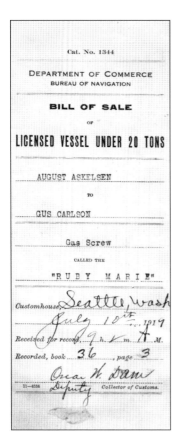

Cat. No. 1344

DEPARTMENT OF COMMERCE
BUREAU OF NAVIGATION

BILL OF SALE

OF

LICENSED VESSEL UNDER 20 TONS

AUGUST ASKELSEN

TO

GUS CARLSON

Gas Screw

CALLED THE

"RUBY MARIE"

Customhouse Seattle, Wash

July 10th, 1919

Received for record, 9 h. ✓ m. A m.

Recorded, book 36, page 3

Oscar W. Dane

Deputy Collector of Customs.

11—4534

Gus Carlson purchased the steam powered *Ruby Marie* in 1919 to haul groceries to his store in Oro Bay and serve his customers. The *Ruby Marie* caught fire early one winter morning and was a total loss. Fortunately, high tide and a covering of snow saved the dock and store. (Courtesy Gene and Lyle Carlson.)

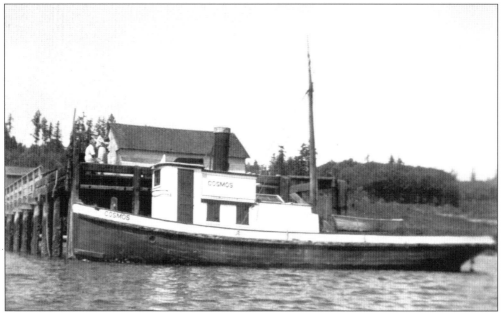

The *Cosmos*, pictured here at the Oro Bay dock by the Carlson's Store, replaced the *Ruby Marie* after it burned. When reliable ferry service commenced, the *Cosmos* was sold, and a Model T truck was purchased for delivery of groceries and goods. (Courtesy Gene and Lyle Carlson.)

The "grid" at Johnson's Landing was used to haul boats out of the water for maintenance. Close to the shoreline, it allowed easy maneuvering on and off the grids. The boat bottoms were scraped and painted. (Courtesy Cindy Haugen.)

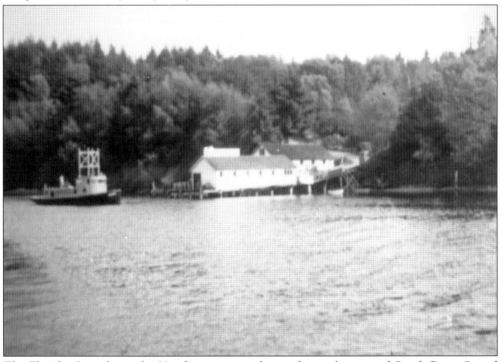

The Ehricke Store boat, the *Vaughn*, was one of many boats that served South Puget Sound as floating grocery stores. Pictured here at Johnson's Landing, the buildings served as a store, warehouse, and living quarters for Ellen and Ernie Ehricke and their son Bob. The *Vaughn* was sold in 1941. Store vessels carried everything from feed to furniture, farm equipment to groceries, and people to cows and chickens. (Courtesy Cindy Haugen.)

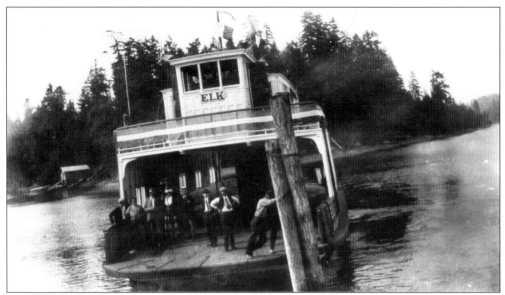

The 67-foot ferry *Elk* was built by the Skansie brothers in 1921 for automobile and passenger service on the Steilacoom–Longbranch–McNeil–Anderson Island route. Under contract to Pierce County, the *Elk* made the first ferry run to Anderson Island on April 1, 1922, with Capt. Bert Bales at the helm. She was eventually sold to Capt. Harry W. Crosby of the Crosby Towboat Company and renamed *Airline*. (Courtesy Gig Harbor Peninsula Historical Society.)

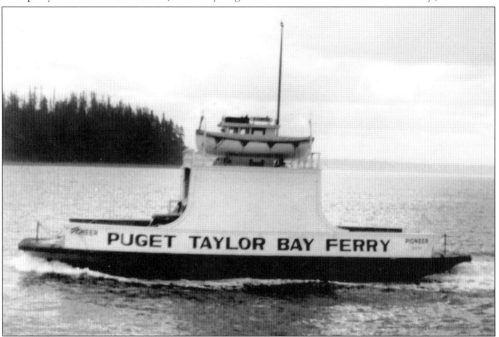

Built in 1916, ownership of the *Pioneer* passed through several hands before being purchased by Berte and Aug Olson in 1932. When the Deception Pass Bridge was built in 1935, she was again sold but was shortened to qualify for the under 65-foot ruling. She joined the *Tahoma* on the Steilacoom–McNeil–Anderson Island route around 1939 as a backup ferry. The *Pioneer* was sold in 1964. (Courtesy Robin Paterson.)

This 1934–1935 ferry schedule shows the owners of the ferries as Washington Navigation Company, with Mitchell Skansie as president. Ferry service was privately run until 1938 when Pierce County took over ferry transportation. Pierce County, contracting the service out, purchased their first ferry, the *Islander*, in 1967. (Courtesy Cindy Haugen.)

Time Schedule

OF

WASHINGTON NAVIGATION COMPANY

MITCHELL SKANSIE, Pres. and Mgr.

Time Schedule

Effective October 1, 1934
To June 1, 1935

STEILACOOM-McNEIL'S ISLAND-ANDERSON ISLAND-LONGBRANCH FERRY — DAILY EXCEPT SUNDAYS

Lv. Longbranch	Lv. McNeil's Island	Lv. Anderson Island	Lv. Steilacoom
6:45 A.M.	7:05 A.M.	7:10 A.M.	8:30 A.M.
9:45 A.M.	10:05 A.M.	10:10 A.M.	1:00 P.M.
2:30 P.M.	2:50 P.M.	2:55 P.M.	3:45 P.M.
4:50 P.M.	5:10 P.M.	5:15 P.M.	6:00 P.M.

SUNDAYS

Lv. Longbranch	Lv. McNeil's Island	Lv. Anderson Island	Lv. Steilacoom
7:30 A.M.	7:50 A.M.	7:55 A.M.	9:00 A.M.
10:30 A.M.	10:50 A.M.	10:55 A.M.	11:30 A.M.
3:00 P.M.	3:20 P.M.	3:25 P.M.	4:15 P.M.
6:00 P.M.	6:20 P.M.	6:25 P.M.	7:15 P.M.

NOTE—Deviation from the schedule time on Saturdays P. M. and Sundays and holidays will be made when necessary to take care of congested traffic by making of more frequent trips.

NOTE—All ferries will run on Sunday schedules on Washington's Birthday, Memorial Day, Fourth of July, Labor Day, Thanksgiving Day, Christmas and New Year's Day.

In 1934, the daily ferry run started in Longbranch, home of owner Skansie Brothers Boat Company. It made four runs a day plus extra trips when necessary to take care of congested traffic. An additional trip today is a rare occurrence. (Courtesy Cindy Haugen.)

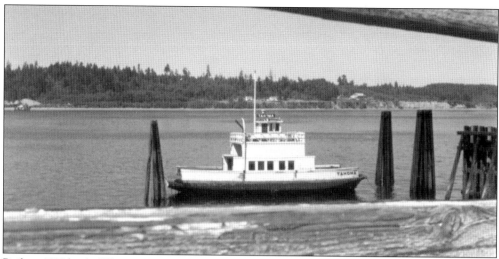

Built in 1933 by the Western Boat Building Company for Olson Ferries in Longbranch, Washington, the ferry *Tahoma* operated at a speed of 12 miles per hour on the Steilacoom–McNeil–Anderson Island route. When ferry service ended in the evening, the *Tahoma* docked on the Anderson Island side. Having a nine-car capacity, the *Tahoma* served the island from 1939 until 1967. (Courtesy Liane Heckman.)

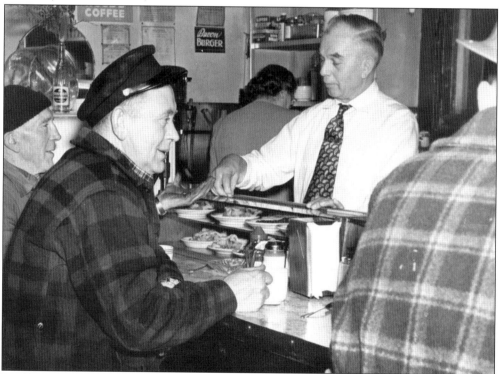

Deckhand Pete James and Capt. Harold Hansen, who skippered the ferry *Tahoma* from 1943 to 1954, enjoy a bite to eat at Don and Maebelle Gordon's Dock Lunch on the Steilacoom dock. Property owners on Anderson Island, the Gordons ran the diner during the 1940s and lived in a house on the dock that also served as storage for supplies. Today the *Tahoma* pilothouse is displayed at the Johnson Farm Museum. (Courtesy Vivian Gordon.)

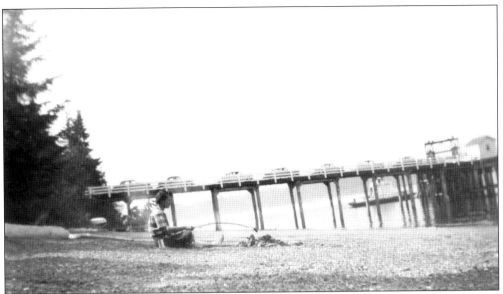

Roasting a frankfurter on a stick in 1940, Edna Burg is not distracted by the long summer ferry line. Islanders often mention the phrase "island time" when anxious visitors express concern about the long wait for the ferry back to the mainland. (Courtesy Jerry and Gail Burg.)

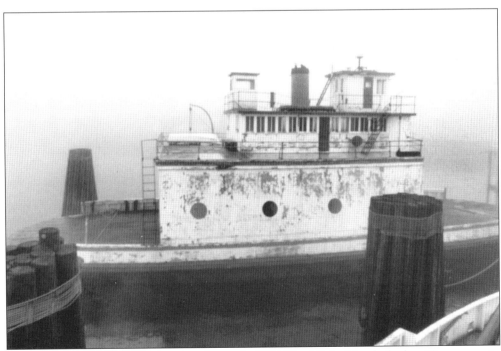

Built in 1924 and affectionately referred to as the "Old Clunk," the *Islander* had an 18-car capacity and serviced Anderson, McNeil, and Ketron Islands from 1967 to 1976 with Capt. Sam Tokarczyk piloting. Islanders recall stormy nights when the deckhand waited for a wave to lurch the ferry before directing cars off one by one during the rise of each wave. (Courtesy Liane Heckman.)

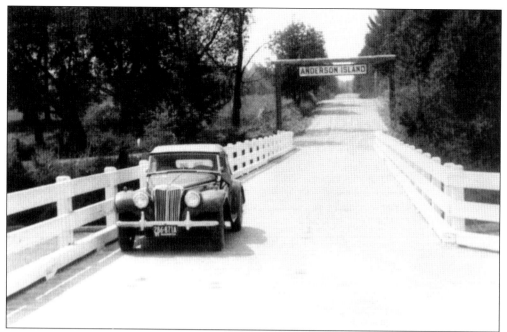

A lone sports car waits in the ferry line around 1960. The overarching Anderson Island sign, which the Anderson Island community club purchased and installed in 1926, can be seen in the background welcoming visitors to the island. Parking was at the side of the road. (Courtesy AIHS.)

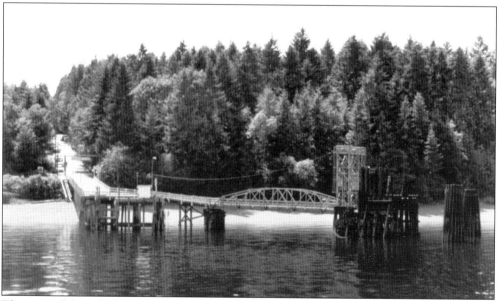

The original ferry dock was built in 1918, with the slip added in 1921. The old Anderson Island ferry dock pictured above made a curve to the north. Built to accommodate the tides, there was rarely ferry dock damage during high winds or tides. The problem, of course, became large trucks and recreational vehicles maneuvering the curve. The new ferry dock corrected this problem but often suffers damage, as evidenced when its float sank in the February 2006 windstorm with high tides. (Courtesy John and Donna Mollan.)

Four

THE McNEIL CONNECTION

A historical perspective of Anderson Island would not be complete without the inclusion of McNeil Island. Two miles wide and three miles long, McNeil, like Anderson Island, was charted by Lt. Peter Puget during his exploration of the South Sound. It was named during Lt. Charles Wilkes's 1841 U. S. Exploring Expedition for William Henry McNeill, captain of the HMS *Beaver*. Over the years, the second "L" has been dropped.

Because of their close proximity, one-half mile apart, and the distance from other communities, these two islands shared many services, goods, employment, and often-friendly rivalry. McNeil had the first store, the first brickyard, eventually three post offices, the first church, two schools, and a library. Sawmills were the main source of economy, supplemented with farming, fishing, and logging. Many residents used boats to take wood to Johnson's Landing for loading on steamships bound for San Francisco and Alaska.

Although there is no known record of a claim, it is generally accepted that Ezra Meeker was one of the earliest settlers on McNeil Island. However, it was not until the Julin family arrived in 1884 that settlement commenced.

In 1870, Jay Emmons Smith deeded 27 acres, possibly the site of Ezra Meeker's settlement, to the federal government for the construction of a prison. The government reimbursed Smith $100 for the land and construction of an island prison was completed five years later. The facility became a federal prison in 1890. In 1936, a vacate order was issued to all islanders when the federal government took over the entire 4,400-acre island for use as a penitentiary. Many islanders moved to Anderson at that time; others moved to the mainland.

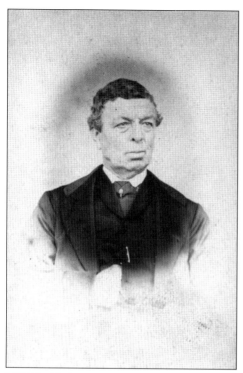

Born in 1803, Capt. William Henry McNeill, a Bostonian, joined the Hudson's Bay Company in 1830 when the HBC purchased the *Llama*, which he skippered. In order to work for the company, he was required to become a British citizen. McNeill took command of the *Beaver* in 1836 and remained her captain until 1851. For assistance provided in 1841, Lt. Charles Wilkes honored McNeill by naming an island for him. Retiring in 1861, McNeill built a home on Vancouver Island and died there on September 4, 1875. (Courtesy British Columbia Archives, Call No. A-01629.)

In 1853, Ezra Meeker, a well-known area pioneer, built a cabin for his wife and young son, about where the main penitentiary now stands. The Meeker family did not stay on McNeil, and in 1862, the property was turned over or sold to J. W. McCarthy. It is unclear if Meeker actually filed a claim for the property. Jay Emmons Smith eventually purchased the property. (Courtesy PSMHS.)

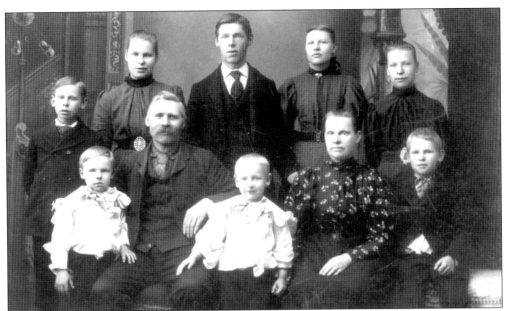

After living with Ida Petterson Julin's parents on Anderson Island for a short period, Carl Johan and Ida Julin moved to McNeil Island in 1884. The Julins, the first family to settle on McNeil Island, had five sons and four daughters. This photograph was taken before the 1902 birth of Nina Julin. (Courtesy Gene and Lyle Carlson.)

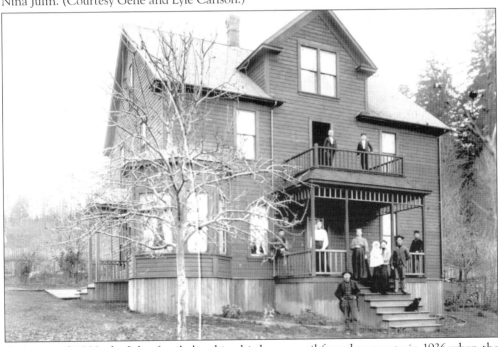

Built around 1900, the Julin family lived in this home until forced to vacate in 1936 when the island became government property. After moving to the island, Carl Julin continued working at Johnson's wood yard on Anderson Island, rowing over on Mondays and returning Saturday evenings. In 1899, he opened a store in Still Harbor, which housed the Gertrude Post Office. (Courtesy Wes Ulsh.)

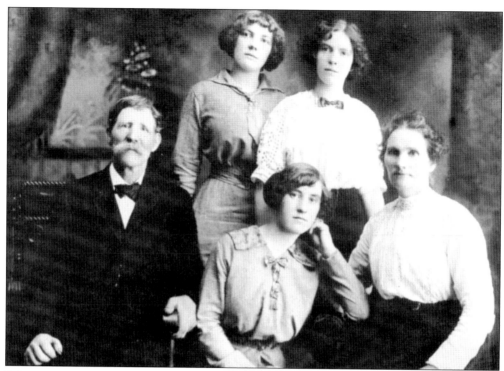

John Holm came to McNeil Island in 1882 and married Petra Nelsen in 1888. Pictured with their three daughters, this photograph was taken about 1912. Their son Edwin died in infancy and was buried on the Holm property. Entwined in tree roots, it is the only pioneer gravesite remaining on the island today. A small cemetery containing about one hundred federal prisoner graves is maintained by the state prison system. (Courtesy Betsey Cammon.)

Hans Olsen Kammen and his wife, Inger Johnsen Kammen, purchased a 40-acre tract of land on McNeil Island in 1887. With three children from a previous marriage, Hans, a widower, and Inger had five more children. Sons Oscar and Martin Cammon, as the name became known, worked at a variety of jobs and finally joined the shrimp fishermen on the sound. Their Cammon Boat Shop was located on the McNeil property. Taxes in 1890, as pictured left, seem minuscule by today's standard. (Courtesy Gene and Lyle Carlson.)

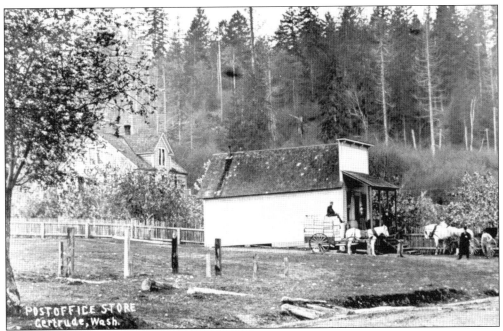

Carl Julin became the Gertrude Post Office postmaster in 1900 when it was housed in his Still Harbor store. At one time, three post offices served McNeil Island, Meridian, Bee, and Gertrude. Established in 1890, Meridian, the first to serve the island, was located on the mainland across Pitt Passage and later moved to McNeil. The Bee Post Office, established in 1895, served the prison and Anderson Island until its closure in 1919. (Courtesy Wes Ulsh.)

Islanders owned horses for farm labor and transportation around the island. This view, from the Julin farm, overlooking Still Harbor, was often referred to as Julin's Bay. St. Anne's Home, reputed to be a house for unwed mothers, owned a large portion of Gertrude Island, to the right. (Courtesy Wes Ulsh.)

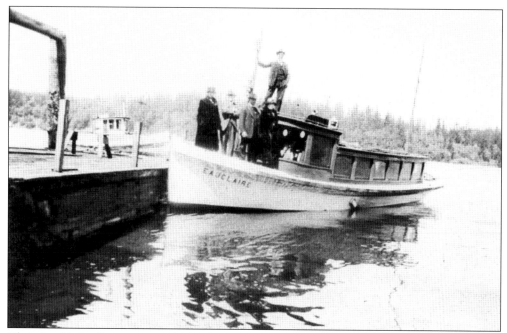

Christina Taylor Parr, appointed Meridian postmistress in 1915, served until 1927. In addition to running the Parr sawmill, her husband, Fleet Parr, used his boat the *Eau Claire* to deliver the mail and occasionally carry passengers. (Courtesy William H. Parr.)

The Gertrude Post Office was named for the small island in Still Harbor, McNeil Island, both pictured above. Carl Julin served as postmaster until his 1913 death. The post office closed in 1936. (Courtesy Wes Ulsh.)

Peter Gulseth, in his apple orchard around 1918, moved to McNeil Island with his wife, Margaret Nelsen Gulseth, and sister-in-law Micca Nelsen in 1899. After the death of their father, the Nelsen daughters, moved to be closer to their aunt and uncle, John and Petra Holm. The Gulseths purchased McCain's General Merchandise Store, and Margaret became postmistress of the Bee Post Office. (Courtesy AIHS.)

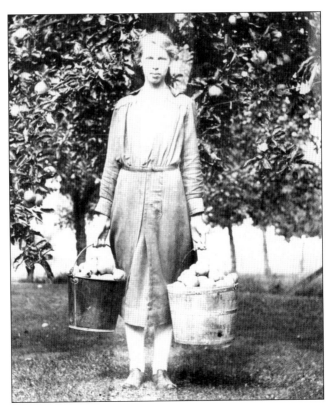

Small family farms and fruit orchards were common on McNeil Island. This photograph of Nina Julin Ulsh, with two buckets of apples, was probably taken during her teenage years around 1918. (Courtesy Wes Ulsh.)

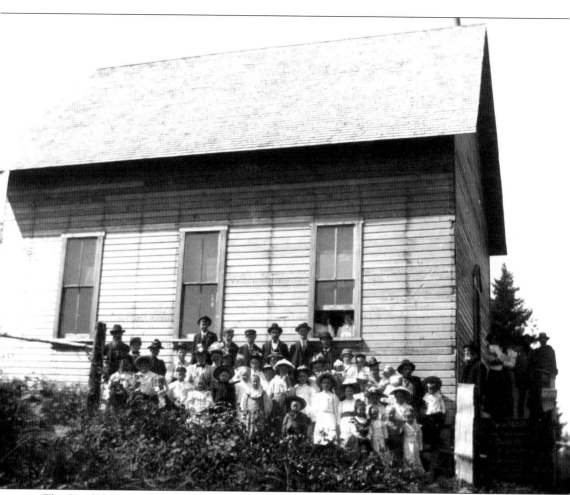

The Swedish Evangelican Lutheran Sunne Congregation of Anderson and McNeil Islands first met in the home of Carl Julin in 1896. Twenty-one adults and 26 children from Anderson and McNeil attended the organizational meeting to elect deacons and trustees and determine whether the church should be built on Anderson or McNeil. Edwin Iverson donated McNeil property northwest of the south side dock. The church, built at the top of a hill, was completed on October 28, 1898. The Anderson Islanders who climbed the hill from the dock each Sunday called it "Klondike Hill." The church, which came to be known as "Sunne," served as both a church and social hall. Holiday celebrations, funeral services, and even the annual Fourth of July picnic were held at the church, which continued to serve both islands until 1936, when the vacate order was issued. (Courtesy Gene and Lyle Carlson.)

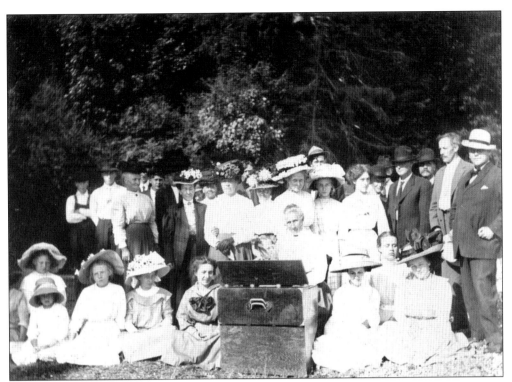

When church was over, dinner was served or a picnic was held, with a social afterwards. James and Caroline Ward of McNeil Island hosted the above gathering. Caroline Schubert Ward is probably playing the portable reed organ often carried by visiting ministers. (Courtesy Dianne Avey.)

March 16 - 1910.

We, the undersigned, have all called to give you a "Baby" shower. Are so sorry you were gone. We extend our heartiest greetings.

Mrs. Hans Cammon.
Mrs. Maass
Mrs. Gustaf Nelson
Mrs. P. Burke
Miss Minnie Cammen
Alice Cammen.
Emilia. Carlson.
Mrs. Bessie Cammon.
Mrs. Hattie Johnson

Although the intended recipient of this surprise baby shower is not known, it was probably a McNeil resident. The women who signed this note all lived on McNeil Island in 1910. (Courtesy Gene and Lyle Carlson.)

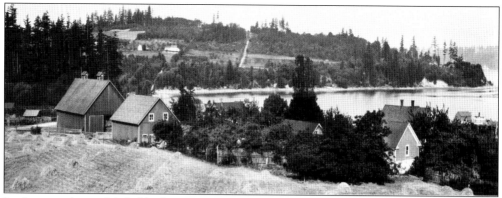

Looking northwest, McGoldrick's Point can be seen in this photograph taken from the Julin farm, with the mainland in the background across Carr Inlet. An elderly couple, John P. McGoldrick and his wife, moved to the point and lived there for many years. It became known as McGoldrick's Point, but it is now called Baldwin's Point. (Courtesy Wes Ulsh.)

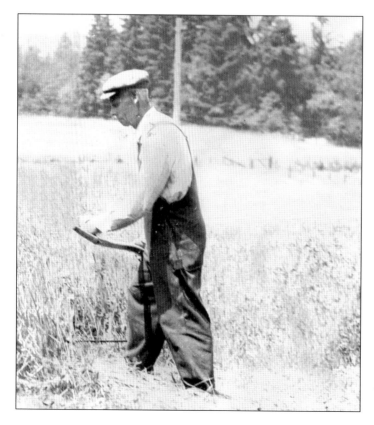

In addition to running the Julin Store in Still Harbor, Carl Julin also farmed. Here he is using a scythe to harvest grass for hay. (Courtesy Wes Ulsh.)

Willis Thomas Parr, center, and his partners, the Norgren brothers, are pictured here shortly after establishing Parr, Norgren, and Company, a sawmill off Pitt Passage on the west side of McNeil. After buying out his partners in 1910 and renaming the mill Parr Brothers Lumber Company, Parr brought his sons Fred and Philetus to McNeil to run the sawmill. (Courtesy Deborah Malafronte.)

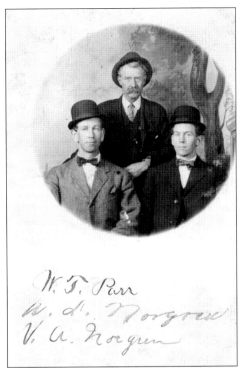

Married in 1877, Willis Parr and Mary Elizabeth VanWoert Parr lived in Durand, Michigan. In 1896, Parr came to Washington looking for work, but his family remained in Michigan until the children were older. Pictured in this 1899 photograph are the Parr children, from left to right, (first row) Lavern, Raymond, Ladonna, and Lyle; (second row) Gertrude, Philetus "Fleet," Esteline, Fred, and Alma. (Courtesy Rupert and Terilyn Burg.)

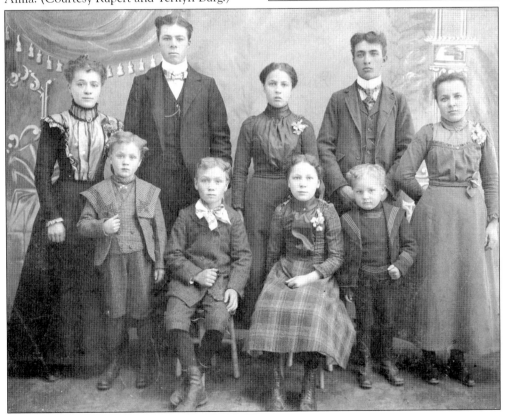

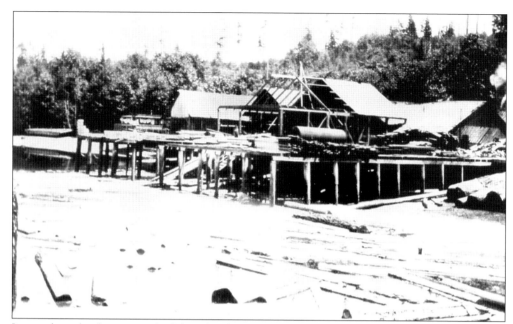

Located on the far west end of the island, the Parr Brothers Lumber Company, pictured here in 1913, was sometimes known as the West End Mill. In addition to producing lumber, the mill also made shingles and fruit boxes. It was destroyed by fire in 1926. (Courtesy Rupert and Terilyn Burg.)

PARR MANUFACTURING CO.,
LUMBER, SHINGLES and FRUIT BOXES
West End Mill, McNeils Island

Meridian,
Tacoma, Wash., June 14, 1918. 191

Mr. O.W.Pearson.

Arletta, Wash.

Dear Sir;

Replying to your letter of the 11th, we are pleased to quote you on the list of lumber submitted $40.84, and on the 4 inch cherry and tomato boxes 8cents.

If you are going to need any of these boxes we would suggest that you get your order in early as we are booking a great many orders and may not be in position to accomodate you should you delay too long.

Yours very truly,

P/OWC
Parr Mfg. Co.

P.S. We can deliver the lumber within two days from receipt of order

This 1918 customer letter from Parr Manufacturing Company in Meridian, Washington, one of the three post offices on McNeil, is a quote for lumber and cherry and tomato boxes. It encourages the customer to submit the order early as they are receiving many orders. (Courtesy William H. Parr.)

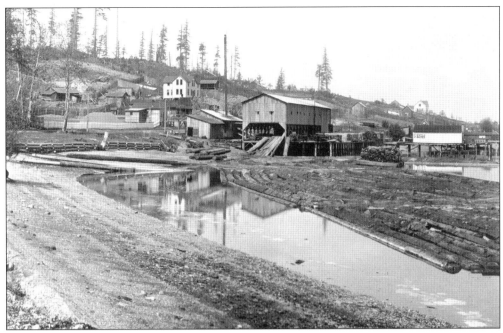

Built in 1908, the Washington Lumber and Box Company was the largest mill on the island. It changed hands several times and was still in existence when the federal government took over. Charles Larson's home can be seen on the hill to the left. (Courtesy Gene and Lyle Carlson.)

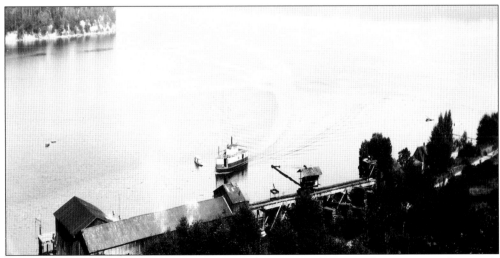

The last owner of the Washington Lumber and Box Manufacturing Company was George A. Misener of Tacoma, who expanded the mill. It became known as the Misener Mill, and many islanders found employment there before it closed in 1936. The Torgenson's freight boat, *Ronda*, can be seen pulling into the dock. (Courtesy Wes Ulsh.)

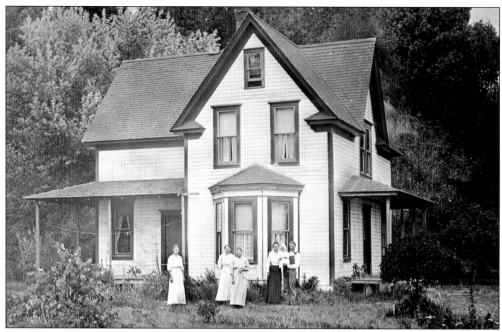

The original owners of this McNeil Island home are unknown, but the house still stands today. It is reputed to have been a brothel for loggers. (Courtesy Gene and Lyle Carlson.)

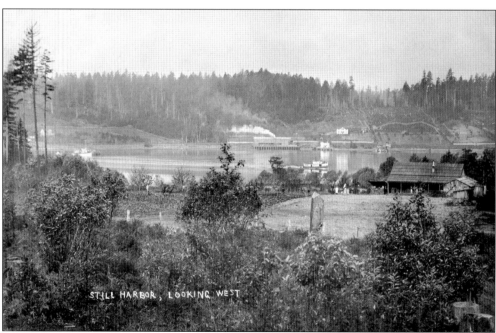

STILL HARBOR, LOOKING WEST

Postcards, or private mailing cards as they were known in the early 1900s, carried photographs of local scenes and individuals. This image, looking west at Still Harbor, was probably taken from the Hadar Miller farm. Miller was the first president of the McNeil Island Library Association and managed the baseball team. After marrying, he left the island and sold the property to Albert and Selma Westrom. (Courtesy Gene and Lyle Carlson.)

A 1914 postcard from Esther Julin of Gertrude to her younger cousin Gerda Engvall of Vega declines an invitation to attend an Anderson Island program. Since Gerda was 15 in 1914, the invitation was probably for a school program. Postcards and letters were a common communication method between the islands, with fishing and grocery boats serving as mail carriers. (Courtesy Gene and Lyle Carlson.)

Nina Julin, left, with her older sister Esther, her father Carl Julin, and her brother Charles pose for a family photograph in the side yard of their home. Appointed postmistress of the Gertrude Post Office in 1913, Esther held the position until her death in 1925. Charles assumed the post afterwards and held it until the post office closed in 1936. (Courtesy West Ulsh.)

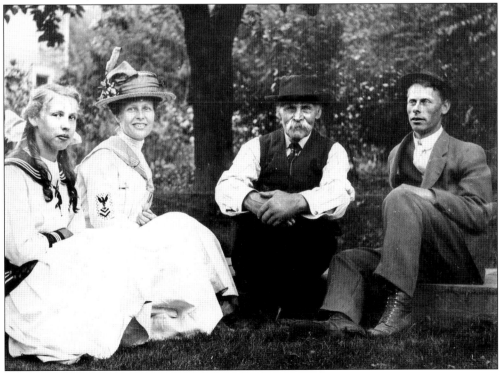

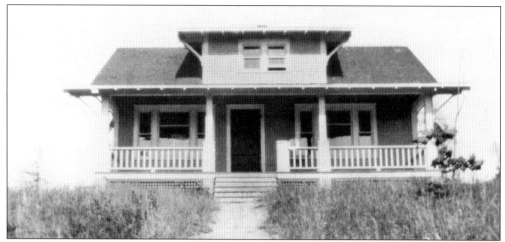

Esteline Parr Olds and her husband, Orrie Olds, joined her father, Willis Parr, on the island in 1926. Expecting to work at the Parr Mill, they arrived just days after it had burned. Orrie Olds found work in other sawmills and purchased this house on McNeil in 1930. Willis Parr lived with the family. Today this house sits on the south shore of the island facing Eagle Island and is used by prison employees. (Courtesy Deborah Malafronte.)

The first McNeil School was established in 1888. When the 1936 vacate order was issued, the school remained open to serve the children of prison employees who resided on the island. The McNeil School, now part of the Steilacoom Historic School District, still serves the McNeil Island K–5 children. A decrease in the school-age population in the 1950s forced the closure of the Anderson Island Wide Awake Hollow School. Anderson Island children traveled by ferry to attend the McNeil Island school until 1980 when a new school was built on Anderson Island. This 1958 Christmas school program, performed on McNeil Island, includes students from both Anderson and McNeil Islands. (Courtesy Vivian Gordon.)

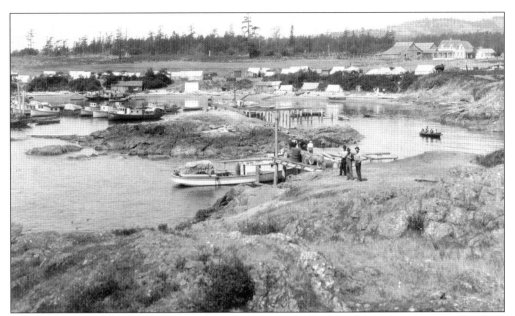

In 1870, the federal government purchased 27 acres of island land from Jay Emmons Smith to build a territorial prison. During the five-year construction, prisoners filled in the above mudflats carrying dirt by hand and wheelbarrows. Today this area houses the fire station, a warehouse, a garage, and a pump station, which pumps water into Butterworth Lake, a reservoir created on the island. Resident homes can be seen in the upper right corner. (Courtesy AIHS.)

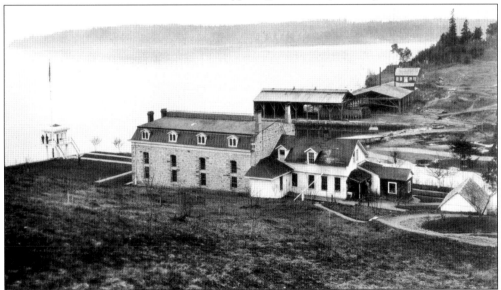

Originally known as the Washington Territorial Prison, the name was changed in 1890 to McNeil Island Federal Penitentiary shortly after Washington joined the Union. When the Federal Bureau of Prisons was established, the government began purchasing all privately owned land on McNeil, with the final vacate order issued in 1936. After the federal prison closed, control of McNeil Island was formally turned over to the Washington State Department of Corrections on July 1, 1981. Taken in 1909, this photograph shows the prison complex looking across Balch Passage to Anderson Island. (Courtesy Tacoma Public Library Northwest Room.)

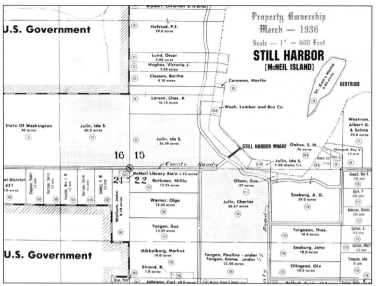

In 1936, when the federal government purchased the remainder of McNeil Island, a map was developed defining all property owners. This portion of the map shows the Still Harbor area. McNeil Island Corrections Center has the distinction of being the last prison in North America located on an island accessible only by boat. (Courtesy Wes Ulsh.)

Determining that the 107-year-old federal penitentiary was obsolete, the Bureau of Prisons decided to close the facility in 1976. Learning this news, the McNeil Island Heirs formed to return the land to the original owners, and the above pamphlet solicits support for their cause. In 1981, to relieve overcrowding, the Washington State Department of Corrections negotiated a contract to lease the prison, and the prison became the McNeil Island Corrections Center, dashing the hopes of the McNeil Island Heirs. (Courtesy Wes Ulsh.)

Five

INDUSTRY
AND SERVICES

Fire was a significant concern for most 19th-century communities since the majority of buildings were wood-frame construction. On June 6, 1889, a devastating fire burned most of Seattle's downtown. A public vote called for the prohibition of any new wooden structures within Seattle's commercial district. As a result, dozens of brickyards sprang up in the Puget Sound area, including Anderson Island and McNeil Island. Employing as many as 24 workers in its 1890 heyday, the Anderson Island brickyard closed five years after it opened—area supply was meeting the demand.

Logging, fishing, and farming were the mainstay of island industry. Christian Christensen established the first wood yard on the shore of his Amsterdam Bay home, as did Bengt Johnson on the north end, both servicing steamboats with cordwood. Other logging operations proliferated, and islanders with farms grew produce for personal use and to sell, along with chickens and dairy products. Others gathered native huckleberries, and for many years, "brush pickers" came to the island picking greens on private land for commercial use.

As the grocery boats faded, local stores opened. The Ehricke Store to the north and the Carlson Store to the south stocked their shelves with groceries and other goods from the mainland, along with island-grown produce. Two island post offices bounced from home to home in the early years. Simon Westby, in his boat the *Roald*, began regular mail delivery from the mainland in 1938, serving both the Yoman and Vega Post Offices.

Intra-island telephone service began in 1917 and full telephone service reached the island in the early 1950s. Electricity finally arrived in 1961, and Pierce County Fire District No. 27 was established in 1979. Cottage industries began to appear in the 1960s providing construction services, automobile maintenance, yard maintenance, real estate agents, a nursery, and a hair salon.

Anderson Island never had a formal main street, a business district, or large commercial buildings. Numerous docks, fishing boats, and two general stores fulfilled the island's needs.

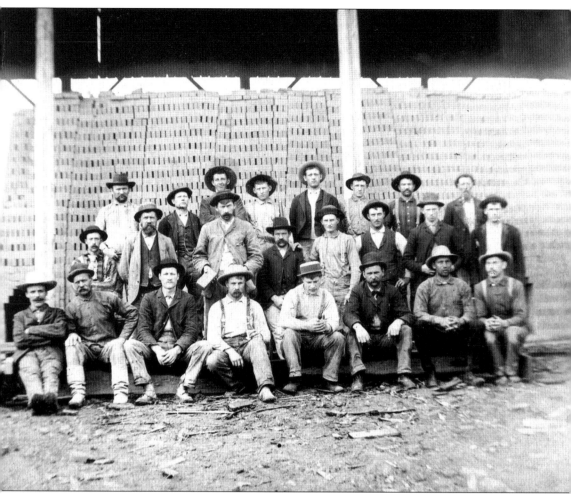

In 1889, brick-making equipment was shipped to Anderson Island from Athens, Pennsylvania, and John Koucher and his son Charles arrived to manage the operation. Employing 24 men in 1890, they posed for this photograph, well dressed and all wearing hats. The brickyard, located on the peninsula that separates Oro Bay and East Oro Bay, closed in 1894. The peninsula became known as Brickyard Point. A March 7, 1894, *Tacoma News* article reported that Charles H. Anderson, the brickyard foreman (first row, third from right), was shot after an altercation with employee Charlie Carlson. Anderson, known to have a hot temper, rode three miles on horseback to the dock, fainting twice. He was placed in a rowboat, and friends rowed him six miles to Steilacoom for assistance. After the brickyard closure, John Koucher and his wife, Elva Ekenstam, moved to Seattle, some employees left the area, and others stayed and worked at the wood yards. (Courtesy AIHS.)

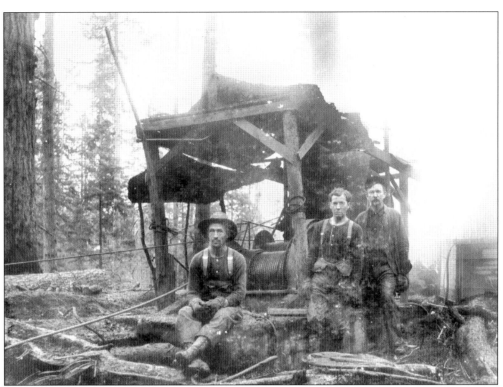

To meet the cordwood demand for steamships, several wood yards opened. Chopping wood was hard work, and loggers were paid far less than the teamsters who did the hauling. This early steam donkey made hauling the logs a bit easier. At the end of each day, woodpiles were measured and each man credited in a record book for the amount he had cut and racked up. (Courtesy AIHS.)

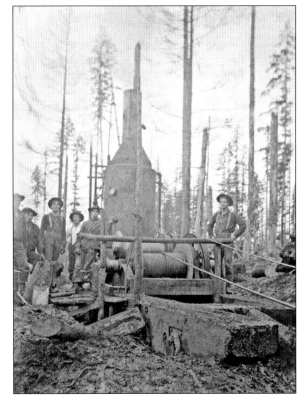

In 1890, the island was considered a good place to work. Paying slightly more than Tacoma area businesses, woodchoppers roomed at various homes or stayed in shacks or cabins. Room and board was $2.50 a week. Logging camps were common, and some workers chose to buy and build their own places. These workers are standing beside the boiler for the donkey engine, used to pull out stumps around 1920. (Courtesy AIHS.)

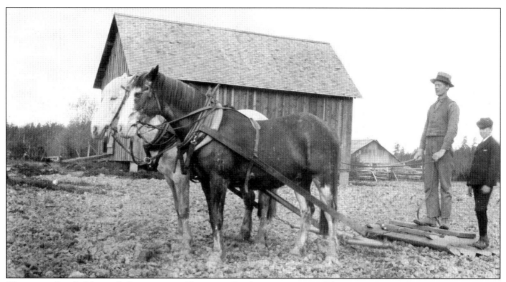

Plowing the fields with his team of horses, Carl Petterson and his son farmed on East Oro Bay. Carl's father, Nels Petterson, raised livestock and had fruit orchards. The barn in the background was built of peeled fir saplings and hand-split cedar shakes. (Courtesy Cindy Haugen.)

Ben Johnson often helped his mother, Anna Johnson, on wash day. In 1916, water was boiled in iron kettles, and ridged washboards were used for hand rubbing. (Courtesy Betsey Cammon.)

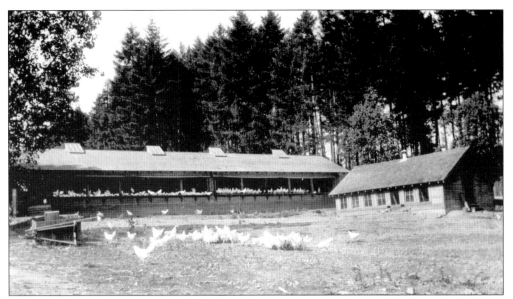

When Else Marie Anderson died in 1915, her daughter Christine assumed the household chores, the gardening, and feeding the chickens. In 1917, she enrolled in Buckley's Washington State Agricultural College and studied new methods for raising chickens. Many other chicken farmers on the island followed her chicken coop design and methods; she was reputed to have the cleanest chicken coops on the island. (Courtesy Bmae and Randy Anderson.)

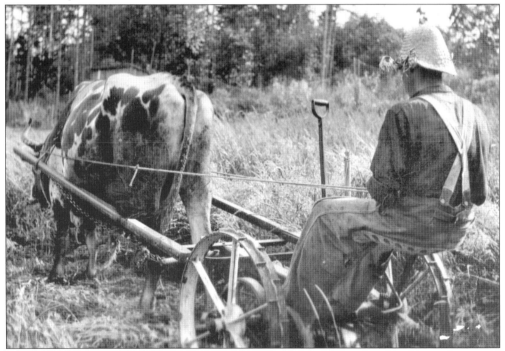

Andy Anderson is pictured above plowing the fields with his ox named Teddy. About 12 years old in this 1907 photograph, he went on to work in lumber mills throughout Western Washington. Several parks on the island have been named for Anderson, who was a charter member of the Anderson Island Park and Recreation Board. (Courtesy Bmae and Randy Anderson.)

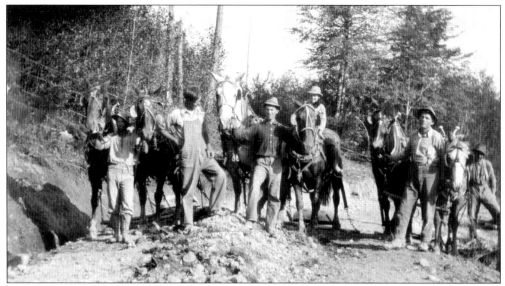

Allan Ostling, born in 1905, is the boy sitting on the horse, dating this photograph to 1915 or 1916. The men are building the East Oro Bay Road, hard work even with horses. Pictured here, from left to right, are Ed Boyd, Oscar Johnson from the Johnson Farm, Peter Sandburg with his team of horses, and Sidor Johnson. (Courtesy AIHS.)

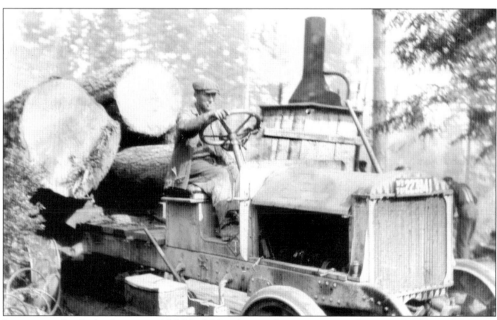

Logging on both Anderson and McNeil Islands was the primary employment in the early 1900s. Logging teams were hired to fell the trees using crosscut saws and axes. The trees were trimmed, cut into lengths, and hauled to the water, then arranged into rafts and towed to the mills. The use of trucks in the 1920s improved the hauling operations of these large trees. (Courtesy Dianne Avey.)

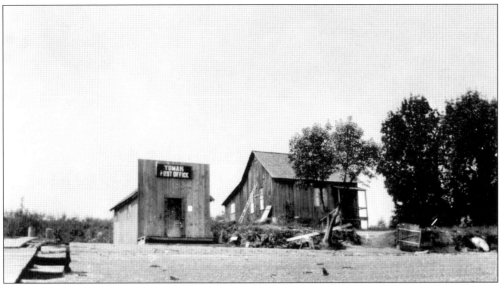

Dan Christensen built this small rustic post office building at Otso Point when his wife, Lena Christensen, was appointed the Yoman Post Office postmistress, which served the north end of the island. Lena was postmistress from 1918 until 1957 when the U.S. Postal Department decided one island post office would suffice. The house next to the Yoman Post Office in the above photograph was the first Christian Christensen home. (Courtesy Lorainne Christensen.)

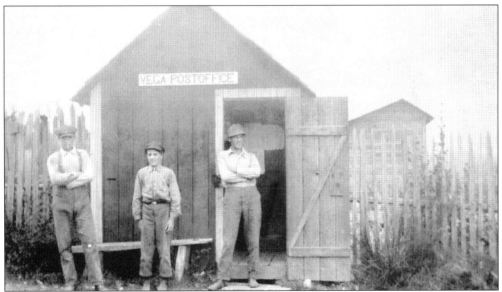

Named for Bengt Johnson's birthplace in Sweden, the first Anderson Island Post Office was called Vega. Established in January 1891, it was located in the Johnson's home at the north end of the island. It was not uncommon for post offices to reside in homes and move as postmasters changed. Sidor Johnson, who became postmaster in 1909, stands to the right of the small roadside shed at Oro Bay. This Vega Post Office location closed in 1933. (Courtesy Cindy Haugen.)

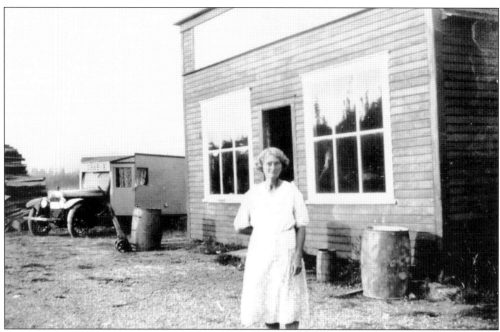

The Carlsons, moving from McNeil in 1914, opened the Carlson Store in Oro Bay. After Gus Carlson died, Emma Cammon Carlson continued to operate the store with her sons and daughter. Selling their grocery boat, the *Cosmos*, in 1940, they purchased the pickup in the background. Roads had improved sufficiently to make deliveries, and ferry availability enabled trips to town. Managed for many years by sons Donald, Lyle, and Gene Carlson, the building still stands today. (Courtesy Gene and Lyle Carlson.)

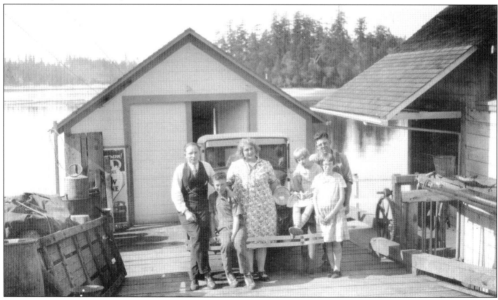

Ernie Ehricke started a grocery store in 1908 on the boat *Vaughn*. He carried butter, eggs, other groceries, supplies, and hardware. Establishing a warehouse at Johnson's Landing in 1912, he eventually opened a store, and his wife, Ellen, did the bookkeeping and managed the store. (Courtesy Cindy Haugen.)

FARM PRODUCE BOUGHT AND SOLD TERMS CASH

PHONE MAIN 5314

E. A. Ehricke

OPERATING THE TRADING LAUNCH VAUGHN

GENERAL MERCHANDISE. HAY, GRAIN AND FEED

WAREHOUSE AT YEOMAN, WASH CITY DOCK, TACOMA, WASH.

As business grew and ferry service was established, Ehricke sold the *Vaughn* and purchased a truck for pickups and deliveries. In 1941, he and Ellen purchased the old Ekenstam property on Villa Beach and moved their operation to a modern store, machine shop, and garage. They also remodeled the existing home. When Ernie Ehricke died in 1951, his wife, Ellen, and son Robert continued to operate the business. The store eventually closed in 1975. (Courtesy Cindy Haugen.)

This 1921 photograph of two men working at Lake Florence reflects the beauty of the lake and shows how sparsely populated it was during this time. Both Lake Florence and Lake Josephine remained undeveloped in the early years because of their interior location and inaccessibility. (Courtesy Betsey Cammon.)

In 1940, Anderson Island had its one and only airfield and hangar on the Ben Johnson property adjacent to the Cammons. Harold Larson (of Tacoma) and Roger and Russell Cammon owned the above plane, *My Baby*, or what is left of it. The Aeronca engine failed shortly after takeoff, sending 18-year-old Russell to the hospital for more than a month. (Courtesy AIHS.)

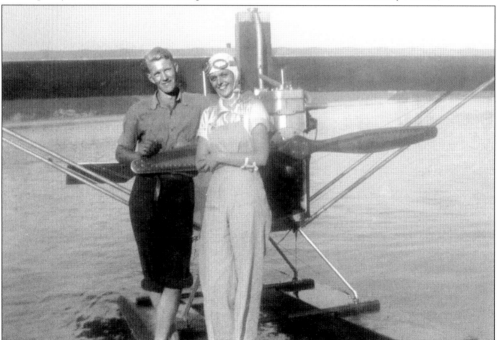

Roger Cammon and Lena Thomsen are leaning against Cammon's Pietenpol Air Camper, a seaplane that he built himself, in the summer of 1937. McNeil Island can be seen in the background of this photograph taken on Dan and Lena Christensen's beach. Roger and Lena, married in December 1937, had the distinction of being the second couple married on the island. Cammon's parents, Oscar and Bessie Cammon, were the first. (Courtesy L. M. Cammon.)

In November 1956, Harold Kooley approached Tacoma City Light about obtaining power for Anderson Island. The response was "too expensive," but that did not deter Kooley. He next met with Bonneville Power Administration, who referred him to the Rural Electrification Administration. REA's Fred Hartt could hardly believe there was a place 12 miles from Tacoma without power. The next step was Tanner Electric Cooperative, and finally power arrived in 1961. (Courtesy Randy Anderson.)

Puget Sound Power and Light finally agreed to "wheel" power from a point at Nisqually Reach but required $25,000 to cover expenses. Tanner Electric was able to obtain a loan and work started. Cable was laid to homes, and the island was energized in November 1961, almost six years after Kooley started his inquiries. Several weeks later, a well-lit dinner-dance celebration was held at the Anderson Island Community Club clubhouse. (Courtesy Randy Anderson.)

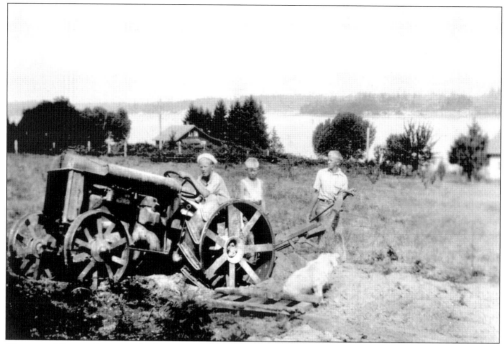

Oscar and Bessie Cammon's three sons—Roger, Russell, and Robert, with their dog Jack—seem to be hard at work clearing land in August 1932. The Cammon house can be seen in the background along with McNeil Island. (Courtesy AIHS.)

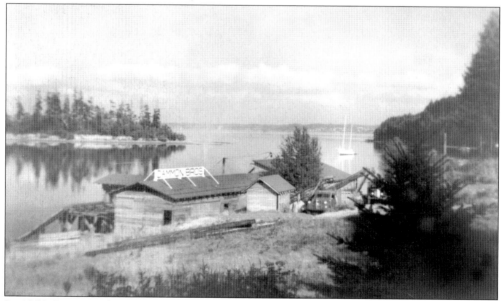

In 1950, Roger and Russell Cammon established a sawmill at Otso Point near Johnson's Landing. The Cammon Brothers Sawmill sold lumber to islanders and several Tacoma mills. In addition to running the mill, the brothers also operated a logging operation. With a Washington State University degree in forestry, Roger Cammon was well qualified to operate this mill. However, in 1956, the mill closed, and the Cammon brothers pursued other careers. (Courtesy L. M. Cammon.)

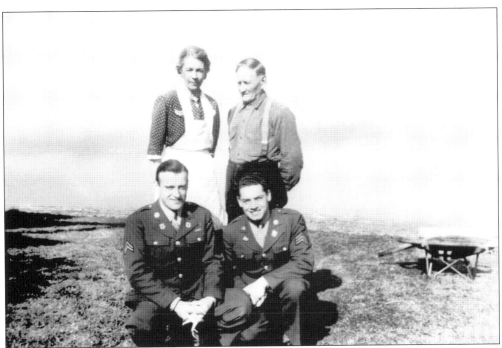

With Fort Lewis in close proximity, island residents often opened their homes to soldiers and served them lunch or dinner. Bessie and Oscar Cammon entertained two Fort Lewis guests, John and Mike, on February 21, 1943. (Courtesy AIHS.)

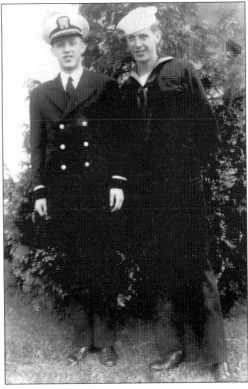

Norman Anderson, left, served in the South Pacific as an ensign in the U.S. Navy. Enlisting at 17, brother Randy Anderson was an apprentice seaman in this photograph. Attending officers training, Randy rose to the rank of captain with the U. S. Navy. A welcome home program for the Anderson Island World War II servicemen was held at the community clubhouse on April 6, 1946. (Courtesy Bmae and Randy Anderson.)

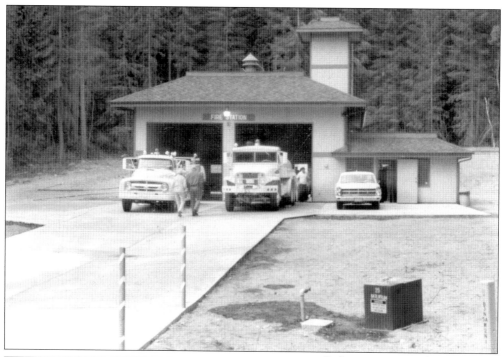

Before an organized fire department, islanders responded to fires via word of mouth or at the sight of smoke. Once the intra-island telephone service was in place, one long emergency ring notified those with phones of the fire's location and instructed them to bring buckets, shovels, axes, and wet gunnysacks for a full assault to extinguish the fire. A fire station was finally built and dedicated in 1981. (Courtesy PCFD No. 27.)

Morris Krepky, Anderson Island fire chief from 1978 to 1982, retired and moved to Anderson Island in the 1970s. As a former Fort Lewis fire chief, he organized the island's first fire department. In June 2000, the fire station was named for him in appreciation for founding the department in 1979. Remembered as an inspirational leader and caring friend, Krepky died in 2005. (Courtesy PCFD No. 27).

The Anderson Island Fire Department conducts a fire prevention program at the elementary school each year. In 1980, Max Stockinger, left, and Bob Nelson give the children a lesson in safety, fire prevention, and fire engine operation. Each year the fire department accepts 16-year-old junior volunteers and assigns them light duty until they are eligible for firefighter training at 18. (Courtesy PCFD No. 27.)

Susan "Pete" Cammon, clowning with Smokey the Bear during a school fire prevention seminar, served Anderson Island residents as station chief and lead emergency medical technician for many years. She recently returned to her hometown in Montana. Islanders miss her caring and kindness. (Courtesy PCFD No. 27.)

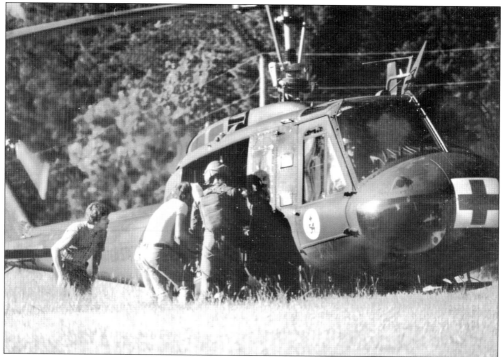

Weather permitting, helicopters evacuate seriously ill or injured patients to local hospitals. The McChord AFB Military Assistance to Safety and Traffic (MAST) provided service at no charge to islanders during the unavailability of commercial service. To thank them for the service, a potluck dinner was held each year for the servicemen and their families. Today a commercial helicopter evacuation off the island costs more than $8,000, but most evacuations are by ferry or the new fireboat. (Courtesy Betsey Cammon.)

The Anderson Island Fire-Rescue (Pierce County Fire District No. 27) has two paid officers and 25 volunteer firefighters, of which eight are emergency medical technicians. This 2003 photograph shows a dedicated, capable fire department ready to handle any emergency. During the February 2006 windstorm, the fire department removed over 150 downed trees from Anderson Island roads. (Courtesy Deborah Ritchie.)

Six

EDUCATION
AND COMMUNITY

First drawn together in 1881 to form an island school and again 15 years later to build the shared Swedish Evangelican Lutheran Sunne Church on McNeil Island, early settlers developed a strong sense of community that still defines Anderson Island today. These native Scandinavians laid the foundation for a community that fosters traditions of volunteerism, kindness, and sharing. Remote and isolated, the location itself forced the islanders to become courageously self-reliant and fiercely independent.

The first community project, the schoolhouse, set the island tone of sharing when Peter Christensen donated 10 acres to construct the new school and carve out a cemetery location. When enrollment dwindled to seven in the 1950s, the same number when the school opened in 1881, children boarded the ferry and traveled to McNeil Island for education, passing prisoners along the way.

In 1968, the Anderson Island Schoo District No. 24 became part of the Steilacoom Historic School District No. 1. Wanting to preserve the old school building, quick-thinking islanders formed the Anderson Island Park and Recreation District, purchased the school, and donated it to the park district. Today, including the old schoolhouse, there are six parks along with 300 acres of recreational facilities, nature trails, and wildlife preserves, all managed by island volunteers. The majority of the park acreage was donated, with the late Andrew Anderson giving about half of the total acreage. Park maintenance is funded by voter-approved taxes.

When the Utopian Social Club of McNeil and Anderson Islands was established in 1904, members from both islands enjoyed many social events, rotating between island homes. It was this early organization that cemented the island culture and developed the traditions. The club, changing names several times over the years, sponsored the Cemetery Association in 1905 and raised funds for the 1917 intra-island phone service. A clubhouse was built in 1930 and is still utilized today as the island meeting hall and main gathering location. Known since 1930 as the Anderson Island Community Club, today it sponsors the annual Labor Day Parade, the Island Fair, and many fund-raisers. This all-volunteer, nonprofit organization typifies the culture that makes Anderson Island such a unique community.

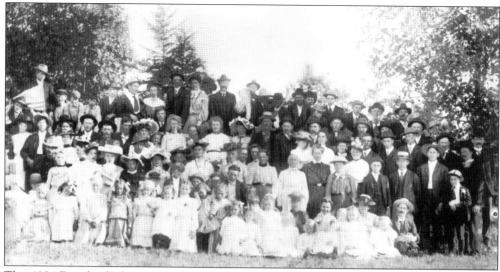

This 1904 Fourth of July picnic at Bengt Johnson's five-acre field shows the sense of community that still exists on Anderson Island today. A traditional island event, the picnic today is an annual salmon bake held at the Anderson Island Historical Society Johnson Farm. (Courtesy AIHS.)

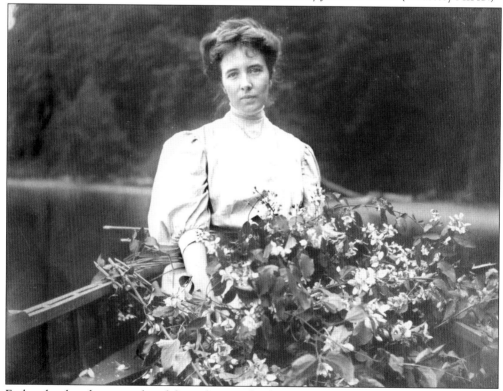

Early schoolteachers were hired from the mainland and required to board with island settlers. They walked the long wooded trails to the schoolhouse, built fires, and served as the schoolhouse custodian. Many teachers served one term and never returned. Mary C. Cox taught for two terms in 1904 and assumed other extracurricular duties. On Friday evenings, Cox boarded a steamship for town but returned Sunday morning to teach a church school class. (Courtesy Dianne Avey.)

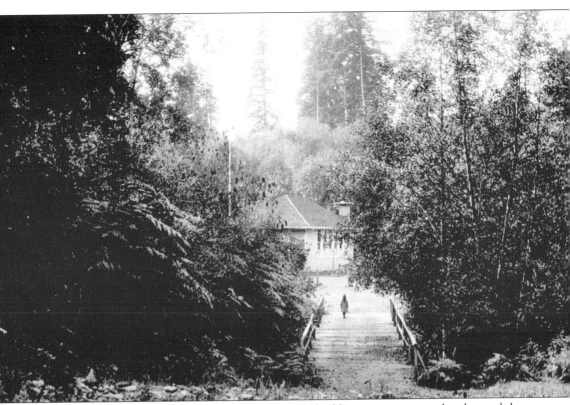

To accommodate the increased population, this 1904 building was constructed and served three generations of island children. As part of a national closure of one-room rural schools and a declining enrollment, it ceased to operate as a school in 1958. Children then traveled by ferry to attend the McNeil Island School until 1980 when a new island school was constructed. In 1968, Andy Anderson, Russ Cammon, Roy Goss, Lowell Johnson, and Larry Gordon spearheaded the formation of the Anderson Island Park and Recreation District to preserve the historic building and served as the first board. The schoolhouse and surrounding property were acquired and donated to the newly formed Park and Recreation District. For over 100 years, this 1904 building, listed on the National Register of Historic Places as the oldest surviving one-room schoolhouse in Pierce County, has served as a school, a meeting hall, a Sunday school, and today houses an exercise club. Ellen Swan, above c. 1918, is crossing the wooden bridge over Schoolhouse Creek leading to the Wide Awake Hollow School. (Courtesy AIHS.)

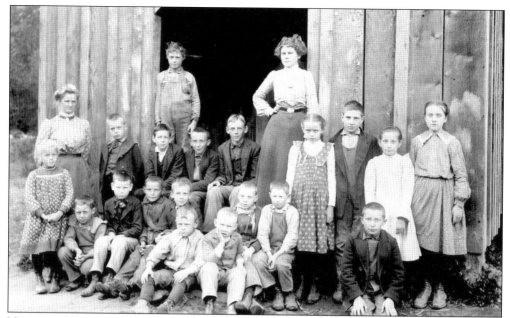

Nineteen students attended the Anderson Island School when this 1901 photograph was taken. An entry was added to the building for lunch pails, boots, coats, and hats. Milk bottles were placed in the cold Schoolhouse Creek water. Children walked a long two-mile wooded trail to reach the centrally located schoolhouse. Traveling through dense forest, the children left fresh fern fronds on the road for those coming behind them. (Courtesy AIHS.)

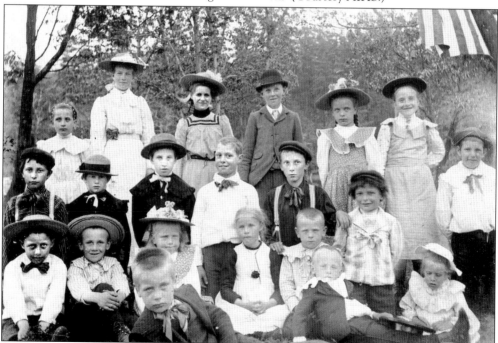

This early 1904 photograph depicts children of the earliest island settlers. Dressed in their best finery as evidenced by the hats, ties, and suspenders, they seem to be having an enjoyable day at a school picnic at the Ekenstam Farm. (Courtesy Earl and Jean Gordon.)

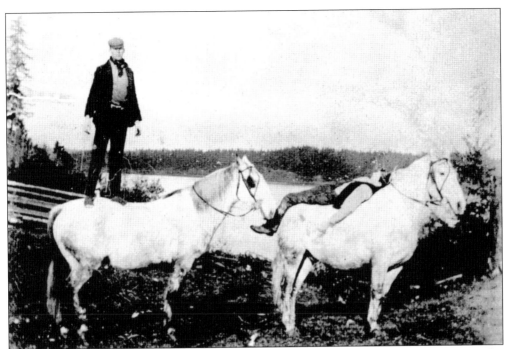

Standing on his horse Harry, Gunnard Johnson poses for the camera while his brother John Johnson, relaxes on his horse, Prince. Having a great time with their skillful antics, the brothers were known for humorous pranks. (Courtesy Betsey Cammon.)

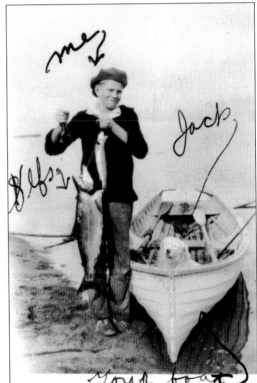

Roger Cammon, with his dog Jack, shows off his eight-pound fish, telling the boat owner he used his boat to land this catch. Rowboats and fishing were great fun for young boys on the island. (Courtesy AIHS.)

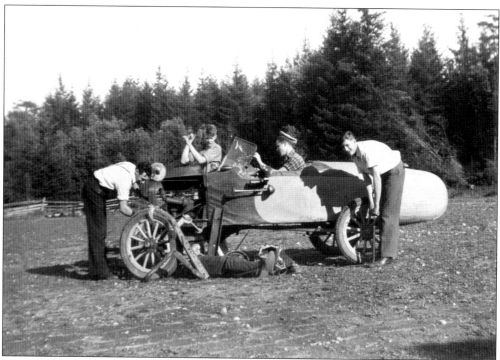

In 1939, the Anderson Island Airport was a good location for island young men to tinker with automobiles and try "new inventions." The Parr brothers and friends are giving it their best effort. (Courtesy AIHS.)

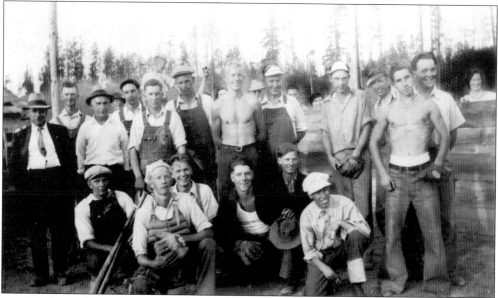

At Linke's Field in 1935, the Anderson Island baseball team, a dynamic group coached by Otto Dewitz, standing left, poses for this photograph. Playing for fun, they gathered and chose sides. Today the Anderson Island Athletic Association, a division of the Park and Recreation District, sponsors many sporting events for young people, including basketball and soccer. (Courtesy AIHS.)

Lowell Johnson Park, the "Swimmin' Hole" on Lake Florence, is one of six Anderson Island Park and Recreation District holdings. It was dedicated 26 years ago in honor of charter park board member Lowell Johnson, great-grandson of Nels and Anna Petterson. During the summer, the park attracts as many as 600 visitors on sunny days to the tree-lined Lake Florence and its crystal-clear blue water. (Courtesy Betsey Cammon.)

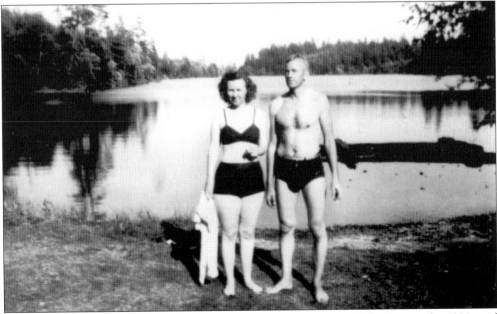

Kitty and Bob Cammon are ready to enjoy a dip in the Swimmin' Hole. During the 1930s and 1940s, the island swimming hole was located on the Engvall property at the west end of Lake Florence. In the late 1960s, the park board purchased the north side Lake Florence property and moved the Swimmin' Hole. Families gather at the park on hot summer days for picnics and swimming. (Courtesy Betsey Cammon.)

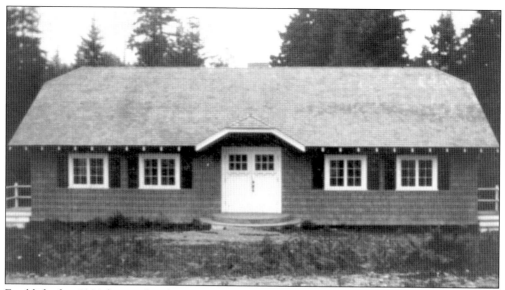

Established in 1904 for social and recreational purposes, the Utopian Social Club of Anderson and McNeil Islands held semimonthly meetings that alternated between island homes. By 1908, the population on both islands had increased and the club was disbanded, with each island forming their own club. Articles of incorporation were filed in March 1930 under the name Anderson Island Community Club. The present-day clubhouse was built with funds members raised, and Nels Warner built the massive interior stone fireplace. (Courtesy Vivian Gordon.)

ANDERSON ISLAND SOCIAL CLUB

NOTICE — RULES

Always listen on the line before ringing, it *may be busy*.

Don't listen to other's conversation on the line, it wears out the batteries and makes poor service, and YOU don't want others to listen to yours.

Five minutes is the limit of conversation at one time.

Please put your phone switch on neutral when you leave home for any length of time.

ONE EXTRA LONG RING IS THE EMERGENCY RING.

L—Long. S—Short.

LIST OF SUBSCRIBERS

South Line — Line No. 1		North Line — Line No. 2	
Andersen, Jens F.	2-L	Baggs, A.	2-L—2-S—1-L
Anderson, Christine	4-L	Baskett, W. J.	1-L—2-S
Camus, Paul	5-L	Burg, Rupert	1-S—2-L—1-S
Carlson, Carl	3-S	Cammon, Oscar	1-L—4-S
Carlson, Mrs. Emma	2-S	Christensen, Dan	1-L—3-S
Clausen, Arthur	2-L—3-S	Ferry Dock	1-L
Dahlgreen	2-S—1-L—2-S	Higgins, R. J.	1-L—2-S—1-L
Dewitz, Otto	1-S—1-L—2-S	Hopkins, Mrs. C. B.	4-S—1-L
Freess, Harry	1-L—1-S—1-L	Johnson, Ben	2-L—1-S
Gordon, Donald	1-L—1-S—2-L	Johnson, Mrs. Hattie	1-L—2-S—2-L
Johnson Brothers	3-L—1-S	Johnson, John A.	2-S—1-L
Johnson, Mrs. Gerda	1-S—2-L	Johnson, Oscar J.	2-L—2-S
Johnson, Dr. Harry	1-L—1-S—1-L—1-S	Larson, Mrs. Lizzie	3-L
Kelbaugh, Ivill	2-S—1-L—1-S	Mercier, A. H.	3-L—2-S
LaRue, Neal	5-S	Potter, Chas.	1-S—1-L—1-S—1-L
Long, Joe L.	1-S—1-L—1-S	School House	4-S
Peterson, Peter	3-S—2-L		
Petterson, Mrs. Dora	3-S—1-L		
Thorberg, Harry S.	2-S—2-L		

The Anderson Island Community Club, known as the Ladies Improvement Club in 1917, was instrumental in raising funds to obtain the first telephone service on the island. Later known as the Anderson Island Social Club, this 1940s directory for the intra-island phone system tells subscribers how many "cranks of the handle" they needed for their calls. (Courtesy Trina Wiggins.)

Built in 1930 on two acres donated by Gunnard Johnson and August Burg, the Anderson Island Community Club clubhouse was, and still is today, the center of island activity. The 1934 members, pictured here, sponsored social events and maintained the clubhouse. In addition to meetings and social events, the community club also houses the island library. (Courtesy AIHS.)

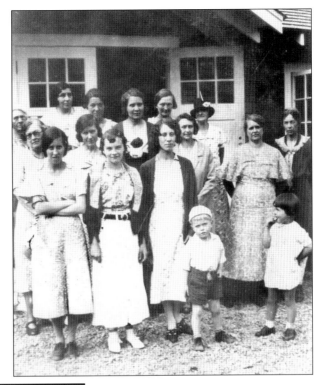

After the 1908 dissolution of the Utopian Social Club, the Anderson Island Sewing Society formed and held barn dances. Once the community clubhouse was completed, the dances and socials continued in popularity until 1961. Many dances were reported to have lasted all night, with visitors coming from Longbranch and Fox Island. This sign, painted by Russ Cammon, was placed outside the clubhouse during the 1950s to advise islanders of an upcoming event. (Courtesy Liane Heckman.)

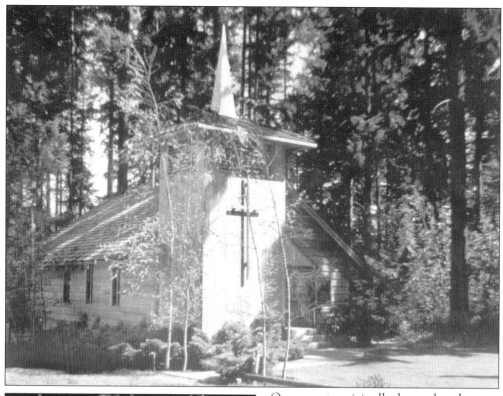

On property originally donated to the community club by Hattie and Gunnard Johnson, island contractor Lowell Johnson built this church, pictured here in 1978, that now serves two congregations. Before the dedication on January 26, 1969, church services were held in private homes and the Wide Awake Hollow School. (Courtesy AIHS.)

In 1883, two acres of the 10-acre tract donated by Peter Christensen for the schoolhouse was set aside for an island cemetery. In June 1905, the Anderson Island Cemetery Association formed. Funded in part by the Ladies Improvement Club, the area was surveyed and cleared in 1916 and an outdoor chapel was built. There were several attempts at signage for the cemetery before it was accurately spelled. (Courtesy Liane Heckman.)

Andrew (left), Christine, and Neils Anderson are pictured on the family's west island property. These siblings were community-minded islanders who made a difference on Anderson Island by serving on boards, donating property, and tackling the tough issues. To honor Christine Anderson, the islanders voted to name the 1994 ferry for her, the MV *Christine Anderson*, which currently serves the island. (Courtesy Bmae and Randy Anderson.)

Founding park board member Andrew Anderson was a true visionary in preserving the way of life that islanders so cherish. He bequeathed 120 acres for a park, now known as Andy's Park, and donated an additional 40 acres for a marine park. In 1990, the above dedication of the Andrew Anderson Marine Park was held. In total, the Anderson Island Park and Recreation District owns over 300 acres of recreational facilities, nature trails, and wildlife preserves. (Courtesy Bernice Hundis.)

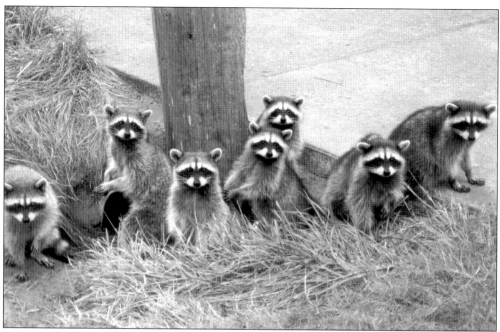

An Anderson Island favorite, raccoons appear adorable but can be a real menace to property and pets. Many charming pictures have been taken of these friendly, photogenic animals. New islanders often make the mistake of feeding these creatures but soon learn what a mistake they have made. (Courtesy AIHS.)

Often seen grazing on the side of the road, deer roam the island indifferent to passing cars. Unaccustomed to the almost tame animals, newcomers stop and take photographs. Despite fencing, islanders often complain that their rose bushes and vegetables have been eaten and chat about what plants are deer-proof. These two appear to be exchanging a kiss. (Courtesy AIHS.)

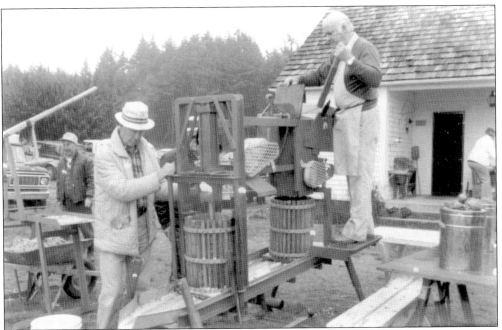

The annual Anderson Island Historical Society's Apple Squeeze uses apples grown and maintained by volunteers on the historic Johnson Farm. Using apple presses borrowed from the Steilacoom Historical Society, "Kope" Kolppa, left, and John Kilgour are preparing the cider for the October 1986 event. (Courtesy AIHS.)

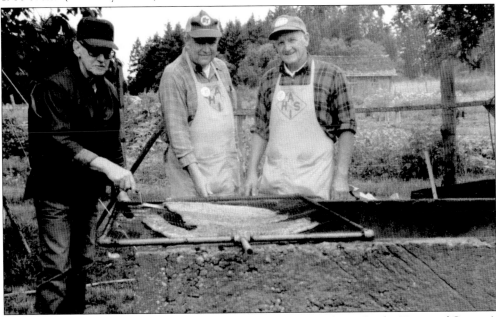

Ken Nibblet, left, Dick Richards, and Roy Goss are preparing salmon for the Historical Society's 1989 Annual Salmon Bake over the Fourth of July weekend. This is the busiest weekend of the year for Anderson Island. First held at Sandy Point, it became such a hit with islanders and visitors, it was moved to the Johnson Farm to accommodate the increasing crowds. The firefighters now help cook salmon and ribs, preparing over 700 meals at last count. (Courtesy AIHS.)

In Noreen Gilpatrick's mystery, *The Piano Man*, she loosely structured her main character in the image of the island's resident celebrity, Roger Russell, to whom she dedicated the book. Russell has performed with ballet companies, is an accomplished pianist, tunes pianos, writes, and is a pretty good ice skater, as pictured here in 1989 on Lake Josephine. (Courtesy Mary Jane Reynolds.)

For many years, volunteer firefighter Bob Nelson has been Santa Claus for the island children at the Christmas star-lighting ceremony. It also gives him the opportunity to have beautiful women sit on his lap. This one just happens to be his lovely wife, Yolanda Nelson. (Courtesy Riviera Community Club.)

Earl and Hazel Heckman purchased the old Baskett home in 1950 for vacation property. Coming to the island on weekends and holidays, they soon retired and moved to the island permanently. In 1967, Hazel Heckman, a freelance writer, published her first and most popular book, *Island in the Sound*, which relates through her acquaintances the history of the island. Her second book called *Island Year* was published in 1972. Heckman died on June 21, 2002. (Courtesy Liane Heckman.)

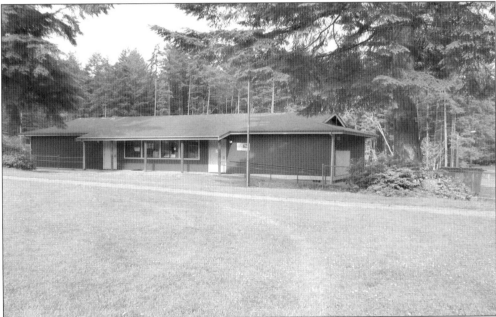

Anderson Island Elementary School, pictured above, opened in 1980 and continues to serve the island's children. When the Wide Awake Hollow School closed in 1958 due to declining enrollment, the Anderson Island children attended school on McNeil Island. (Courtesy Dave Galentine.)

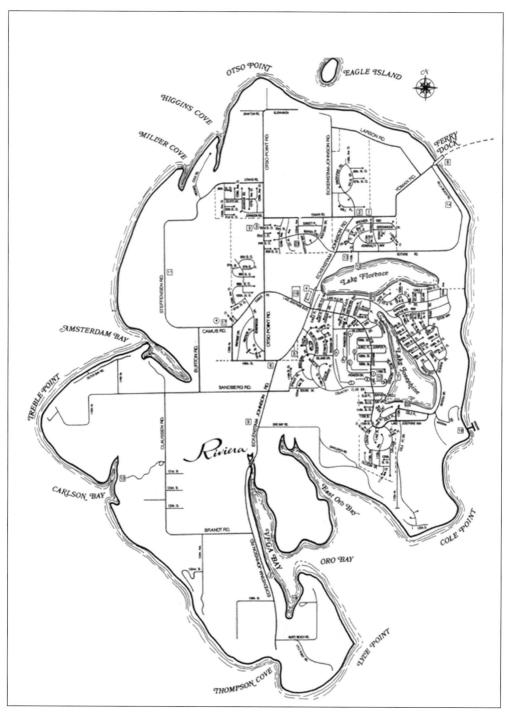

This current Anderson Island map reflects the Riviera Community Club development with its numerous streets and cul-de-sacs. The "Riv," as it is known, includes a golf course and pro shop, a marina, a restaurant, and a business office. (Courtesy Riviera Community Club.)

118

Seven

THE FUN YEARS

In the early 1960s, Bob Hess developed 32 lots on the south end of Lake Josephine. Calling the development Surf and Sands Estates, the lots were purchased for vacation homes, full-time residences, and investors. Five years later, Heritage Properties, Inc. purchased a large tract of land and slowly began buying other tracts. By the late 1960s, it was apparent a large development was looming on the horizon. Longtime islanders just ignored the activity and made a pact not to participate. But gradually, as more lucrative offers were presented, some islanders sold their land. Riviera Community Club, Inc. purchased the holdings from Heritage in 1966 and the rest, as they say, is history.

Today the Riviera Community Club has 3,100 lots with paved roads, electricity, water hookups, and numerous small parks. Approximately 800 homes have been built on these lots by retirees, working families, and summer owners. The combination of one additional evening ferry run in 2004 and the national real estate boom makes it is easy to understand why Anderson Island has been rediscovered and is experiencing a surge in new residential construction. Islanders, who were here in the 1960s, just accept it and move on. Many residents express concern over "paradise" being found and the impact on island resources.

But island life goes on, and community-minded volunteers encourage new residents to get involved and help maintain the quality of life that is so precious to those who live here, reminding them why they moved here in the first place. The Anderson Island Association, the largest organization on the island, still reports the news in their 25-year-old monthly newsletter, the *Island Sounder.* Snowbirds return and the summer people still flood the island from Memorial Day to Labor Day. Visitors continue to remark how isolated it is and how the island almost seems frozen in time. They express surprise at how friendly islanders can be and show amazement when someone waves to them.

The Riviera Community Club marketed lots as vacation property during the early 1960s. Today a desirable place to live, it boasts a golf course, a business office with meeting rooms, several parks, two fresh water lakes, a restaurant, and a marina. Called a country club in the early days, the name was later changed to Riviera Community Club. (Courtesy John and Donna Mollan.)

The Men and Women's Riviera Golf Club is gathered at the Riviera Marina for an awards picnic. Holding the signature Riviera sign "for the fun years," they enjoy many gatherings such as this one. (Courtesy Riviera Community Club.)

A devastating fire destroyed the Riviera Community Club business offices on the evening of July 23, 1999. Determined to be arson by the Pierce County fire marshal, the perpetrator was never caught. All records and historical pictures were lost in that fire. Rebuilt over several years in the early 2000s, the new larger facility now has an all-purpose room for meetings and gatherings in addition to the business offices. (Courtesy Betsey Cammon.)

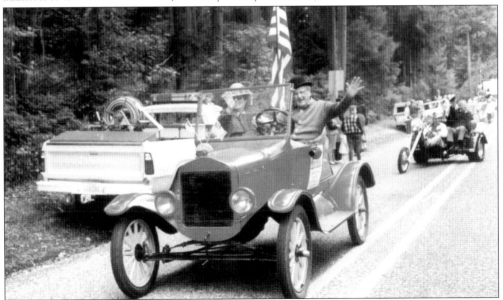

Bernice Hundis, 1989 Woman of the Year, waves as Ray Walberg drives an antique car in the Labor Day Parade. Sponsored by the Anderson Island Community Club, the parade and fair commences at the Island General Store and proceeds one-half mile to the community clubhouse. An all-day event, the fair holds auctions, conducts games for children, presents awards for gardeners, sells hot dogs and hamburgers, and has many other activities. A handmade quilt is raffled at the fair each year, a tradition that started in the early 1940s. (Courtesy AICC.)

The Anderson Island Firefighters Association has a dunk tank at the fair each year, giving islanders the opportunity to dunk their firefighters. The first up to toss a ball at assistant fire chief Jay Wiggins in 1990 was his wife, Trina Wiggins. Purchasing seven balls, she nailed him with the first one. (Courtesy Andy Hundis.)

The Anderson Island Association annually solicits nominations to select the man and woman making a significant contribution to improve the quality of island life. The 2005 recipients, Judy Beck and Ralph Barsanti, led the Labor Day Parade. The AIA, the largest island organization, was formed in 1981 to provide a public forum where island issues could be discussed and taken forward to Pierce County. (Courtesy Darrell and Judy Beck.)

Tom White moved to the island in the early 1970s as a young army officer. After leaving the service, he worked for Bob Ehricke and eventually purchased the business renaming it White's, Inc. White was a teacher for several years and a member of the Steilacoom Historical School District Board. A member of many island organizations, he is remembered for his involvement with young people, his dedication to education, and his contribution to making the island a better place to live. White died in December 2004. (Courtesy Andy Hundis.)

On New Year's Day, the annual polar bear jump participants line up at the ferry dock to take the big plunge. On January 1, 2004, the thermometer read 38 degrees, and the water temperature registered a chilling 47 degrees. Cheered on by loud applause from onlookers, nothing stopped these brave souls from jumping. (Courtesy Sarah Garmire.)

The Russian cargo ship *Monchegorsk* ran aground September 5, 1998, at Amsterdam Bay. Witnessing the starboard turn into the small inlet rather than Balch Passage, which runs between Anderson and McNeil Islands, island residents sitting on their decks were quite shocked as the ship came within yards of their homes. (Courtesy Betsey Cammon.)

Looking west across Oro Bay, this 1983 photograph of Mount Rainier reflects one of the many panoramic views from the island. Oro Bay, once the 1792 campsite of Peter Puget, is now home to the Oro Bay Yacht Club and serves as an outstation for the Bremerton Yacht Club and the Tacoma Yacht Club, berthing upward of 150 vessels during the summer months. (Courtesy AIHS.)

Longtime resident Martha Smith was a true asset to the Anderson Island community. Responsible for founding the high-school senior scholarship fund, she also established a poetry and short story contest at the island school, formed the island reading group, served on many boards, and was the first woman Riviera Community Club board president. In 2003, Martha Smith moved to Vancouver to be closer to her daughter. She is greatly missed by islanders. (Courtesy Dave Galentine.)

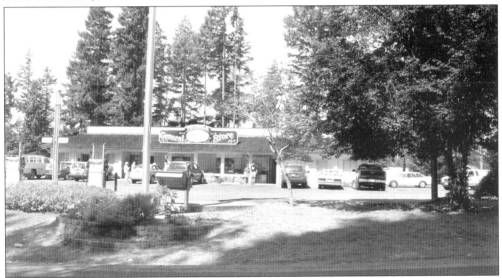

Owned by the Gillettes and the Billetts, the Island General Store is the nerve center of the island. In operation since 1976, this store serves as the grocery store, gas station, hardware store, deli, and post office and is "downtown" Anderson Island. The latest gossip can be heard, rumors are started, and current island news is found here. If islanders want to know what is happening, they just go to the IGS and ask. (Courtesy Dave Galentine.)

A snowstorm struck the area on February 17, 1990, and Vera Wood captured this beautiful arching tree scene over Ekenstam-Johnson Road. Exactly 16 years later, on February 17, 2006, a fierce windstorm struck the island, felling over 150 trees across roads, disabling the ferry dock for five days, and downing electric and phone lines for three days. In true island form, volunteers jumped into action, with neighbor helping neighbor. (Courtesy Vera Wood.)

The anonymous "flower fairy" first made deliveries in the spring of 2005. Carolyn Spaulding, one of the first recipients, found cut flowers in a vase with this note on her doorstep. The fairy works after dark, dropping flowers off, ringing doorbells, and disappearing into the night. Despite the speculation, the identity remains a mystery, and flowers continue to be delivered. (Courtesy Carolyn Spaulding.)

126

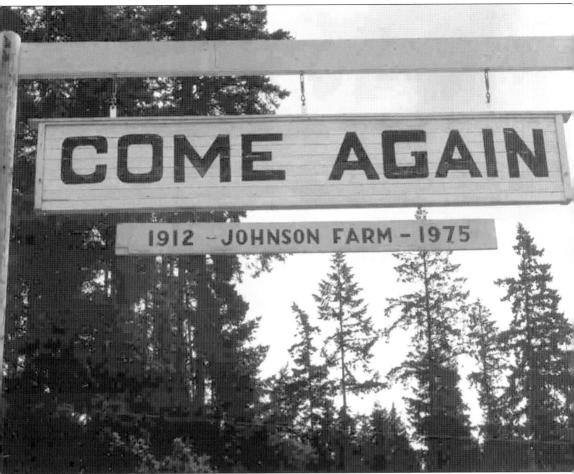

In 1926, the Anderson Island Community Club members had the sign "Anderson Island—Come Again" erected at the ferry dock. During construction of the new ferry dock in 1984, Pierce County removed the sign. Screams of protest to return the sign to its original location did not help, as the county cited safety and liability concerns. Wanting to preserve island history, several islanders approached the Anderson Island Historical Society requesting that the sign be placed at the entrance to the historic Johnson Farm. Today the sign stands at that entrance and serves as a reminder of the island tradition to welcome visitors and invite them to return. (Courtesy AIHS.)

ACROSS AMERICA, PEOPLE ARE DISCOVERING
SOMETHING WONDERFUL. *THEIR HERITAGE.*

Arcadia Publishing is the leading local history publisher in the United States. With more than 3,000 titles in print and hundreds of new titles released every year, Arcadia has extensive specialized experience chronicling the history of communities and celebrating America's hidden stories, bringing to life the people, places, and events from the past. To discover the history of other communities across the nation, please visit:

www.arcadiapublishing.com

Customized search tools allow you to find regional history books about the town where you grew up, the cities where your friends and family live, the town where your parents met, or even that retirement spot you've been dreaming about.